LOST
BREWERIES
OF **TORONTO**

LOST
BREWERIES
OF TORONTO

JORDAN ST. JOHN

THE
History
PRESS

Published by The History Press
Charleston, SC 29403
www.historypress.net

Copyright © 2014 by Jordan St. John

All rights reserved

First published 2014

ISBN 978-1-5402-1138-5

Library of Congress Cataloging-in-Publication Data

St. John, Jordan.
Lost breweries of Toronto / Jordan St. John.
pages cm
Includes bibliographical references and index.
ISBN 978-1-62619-666-7
1. Brewing industry--Ontario--Toronto--History. 2. Breweries--Ontario--Toronto--History.
3. Beer--Ontario--Toronto--History. I. Title.
HD9397.C23T667 2014
338.7'6634209713541--dc23
2014036944

Notice: The information in this book is true and complete to the best of our knowledge. It is offered without guarantee on the part of the author or The History Press. The author and The History Press disclaim all liability in connection with the use of this book.

All rights reserved. No part of this book may be reproduced or transmitted in any form whatsoever without prior written permission from the publisher except in the case of brief quotations embodied in critical articles and reviews.

CONTENTS

Acknowledgements 7
Introduction: The Queen City's Evolution from 1800 to 1914 9

1. Toronto's First Breweries, 1800–1853 17
2. John Doel's Brewery, 1827–1847 23
3. John Farr's Brewery, 1820–1888 27
4. The Helliwell Brewery, 1820–1847 33
5. Joseph Bloore's Brewery, 1830–1864 45
6. Enoch Turner Brewing and Distilling, 1831–1855 51
7. Cayley and Nash's Ontario Brewery, 1848–1857 55
8. John Severn Breweries, 1832–1886 59
9. Spadina Brewery, 1837–1894 65
10. John Walz/Ignatius Kormann Brewery, 1857–1944 69
11. Thomas Allen/Lothar Reinhardt East End Brewery, 1862–1957 77
12. William Copland Breweries, 1830–1946 87
13. Cosgrave Brewery, 1844–1960s 97
14. O'Keefe Brewery, 1840–1960s 105
15. Toronto Brewing and Malting Company, 1859–1967 115
16. Thomas Davies and the Don Brewery, 1846–1907 127
17. Robert Davies and the Dominion Brewery, 1878–1936 137

Selected Bibliography 149
Index 153
About the Author 157

ACKNOWLEDGEMENTS

Thanks should go out to Alan McLeod, my co-author on the previous book, *Ontario Beer*. Thanks also to Sean Duranovich for providing images of the Dominion Brewery in operation. Thanks to Robin LeBlanc for proofreading bits of the book and for her patience with the daily research epiphanies. Thanks to the National Archive of Canada, Thomas Fisher Rare Book Library at the University of Toronto and to Larry Sherk. A book like this isn't possible without the work of pioneers like Ian Bowering and Allen Winn Sneath. Additionally, to the men and women who must have spent years archiving the nineteenth-century newspapers from the city of Toronto, I almost certainly owe you a beer. I would also like to acknowledge Jon Downing and Ron Pattinson for helping bat around contemporary brewing information.

Introduction
THE QUEEN CITY'S EVOLUTION FROM 1800 TO 1914

The most helpful thing you can do to put yourself in a mindset conducive to understanding Toronto is to remember that two hundred years ago, nearly every piece of land within one hundred kilometers was completely covered with forest. It is not an exaggeration to say that only a short time ago, there were bears and wolves roaming the Don and Humber Valleys. The wilderness was vast, and the land was largely untouched. The bounty was plentiful. In some places, there were so many wild pigeons that you could simply swat them out of the air for your supper. You would not want to try that now.

Although York was not initially meant to be the capital of Ontario, John Graves Simcoe's decision to use it as a makeshift administrative centre in the early days of Upper Canada would eventually cement it in that role. The capital was meant to be London, the inland position of which made it less immediately accessible to incursions by American troops. Because of the rapid growth of the town of York and its importance as a centre for trade and governance, the changeover never transpired.

The story of Toronto's growth throughout the nineteenth century depends greatly on the fact that there was initially a powerful, entrenched political class of the kind that could be found in any British colonial settlement at the time. Around the powerful central oligarchic structure of the Family Compact sprang all the trade, manufacturing and agriculture that allowed the rapid growth of the city. Sometimes this happened in spite of the bureaucracy.

Introduction

For most of the nineteenth century, the population of Toronto increased at a phenomenal rate, frequently doubling in a decade. Some of the city's early organizers were students of Thomas Malthus and applied the theories of his *Essay on the Principle of Population* to the development of York and its environs. Upper Canada sought Irish immigration long before the Great Famine. Those immigrants would drive the construction of the Grand Trunk and Great Western Railways and the settling of the frontier.

Toronto derived massive economic benefit from its position at the centre of a constantly expanding agricultural network. As a booming city, it required tradesmen of all stripes. It was not an era of specialization. Today, one might choose simply to be a brewer, and with enough talent, one might make a living at it. In Toronto of the nineteenth century, there was greater opportunity to take on additional roles. Throughout the histories related in this book, the common thread tends to be the involvement of Toronto's brewers in the development of the city.

In arenas political, religious, financial and mercantile, the history of Toronto is inseparable from that of its breweries. Many of the memoirs and histories written about the city in the late nineteenth century (those of Henry Scadding, John Ross Robertson and W.H. Pearson) were penned during a period when temperance was on the march. I do not debate that some form of temperance was needed. In the early part of the century, even the Methodists were brewers, which is a very bad sign for the sobriety of a population. I will suggest to you that the mood of the city at the time shied away from acknowledging the positive contribution of the manufacture of alcohol.

The idea of "Toronto the Good" is bound up with late Victorian morality. It is a staid and thoroughly repressed representation that tends to whitewash the baser needs of an exploding metropolis. The flipside of that image is that of Hogtown, the grimier manufacturing and meatpacking side of Toronto's heritage that helped to pay for the grand buildings that still dot our landscape. Toronto's brewers occupied a space between these two realities. On a daily basis, they would encounter neighbours who occupied each. Their stories offer important insights into the development of our city.

Introduction

From the Queen City to the Greater Toronto Area

If you live in Toronto, you know that one of the things that we're best at is tearing down old buildings and replacing them with less historic properties. It may seem like a recent development, but I can guarantee you that this has always been the case, even if the new buildings were not always condominiums.

Over the course of the late nineteenth and early twentieth centuries, Toronto went through rapid and fairly significant changes to its layout and geography. In places throughout this history, I will need to make reference to various facets of the city's geographical development to spare you hours of poring over obscure fire insurance maps. For that reason, I'm going to try and illustrate some of the core concepts that crop up frequently enough to be of universal importance.

The Garrison

Fort York began construction in 1793, and the museum that exists today stands on the site of the original buildings. Unlike other military fortifications within Ontario, Fort York is primarily of wooden construction, a fact that reflects the haste in which it was built. For a brief period, the administrative capital had been Niagara-on-the-Lake. It was a poor choice for a number of reasons, the greatest of which was its proximity to America.

Upper Canada had originally been part of the province of Quebec, the territory that once stretched down into the Ohio Valley and west into Michigan, Illinois and Wisconsin. The problem had been that very few people actually lived within that territory; in practice, its ownership was in some dispute. A full set of battlements like those at Fort Frontenac in Kingston would have been wasted in the towns of York or Niagara. It would have been difficult to provision and garrison. It would have been tactically inflexible. In a territory of that size, an invading army might simply go around.

Fort York was more deterrent than anything else. For one thing, it was larger than the settlement it protected. In 1812, during the Battle of York, the combined British, Loyalist and native forces totalled 750. That year's census put the entire population of the town at 700. In its only significant military engagement, in 1813, Fort York fell due to overwhelming enemy numbers and poor organization amongst its defenders. Retreating British

Introduction

troops blew the powder magazine, creating an explosion that could be heard across the lake in Niagara Falls. In terms of the growth of the city of York, the soldiery was vastly more useful as a steadily paid set of customers than as a defensive force.

That being said, much of Toronto's early layout depended on the presence of these troops. The downtown area would expand in the direction of Fort York, if only to take advantage of the commercial possibilities these men represented. Breweries especially had an interest in providing beer to this captive audience, especially after the daily ration of six pints was replaced with a penny-per-day allowance in 1800.

The Concession System

Ontario was laid out by surveyors long before people ever occupied farms across the landscape. The government allowed the land that it owned to be sold in carefully measured parcels called lots. The act of conceding the land for sale in carefully regimented sizes meant that the roads acting as divisions between the parcels of land were called concession roads.

Before the coronation of Queen Victoria, Queen Street was called Lot Street because it was the baseline by which all of the land to the north was divided. Alpheus Todd's 1834 map confirms that even in those days, Yonge Street stretched to Lake Simcoe. The distance between each concession road is 1.25 miles or 2 kilometers. From the baseline of Lot Street, Bloor was the first concession, followed by St. Clair, Eglinton and Lawrence. This made for uniform lots of one thousand acres.

In 1834, the population of nine thousand lived south of Lot Street for the most part. Yorkville was a separate town near the first concession, although it would be subsumed fifty years later. It was not uncommon for early settlers near Toronto to own thousands of acres, which they could parcel and sell off to later settlers.

The Don

Traditionally, the Don represented the eastern boundary of the city of York. The river and valley are themselves the product of glacial recession.

Introduction

At the time of settlement, the Don Valley was a desirable location for all manner of business that required flowing water for power or as a resource in manufacture.

The course of the river created significant problems for the businesses operating along its banks. For one thing, a rapid thaw in the spring could send great wedges of ice downstream at destructive speeds. Unseasonable rain could mean floodwaters as high as ten feet. The potential for the river to change course over decades would also have a great impact on the value of the lands along it.

The course of the river was straightened south of Bloor Street in the 1880s. The outflow into Ashbridges Bay had become highly polluted due to the effluence emitted from slaughterhouses, packing plants, breweries and brickworks. It was redirected to flow into Toronto Bay. This means that the locations of several nineteenth-century breweries made sense in relation to a river that has since been moved.

The Harbor

At the time of settlement, Toronto ended at Front Street. In the first half of the nineteenth century, the fastest way to travel was by steamboat. For that reason, wharves were essential to the business of the day, and whether they were operated for the transportation of goods or passenger travel, they were a priority. With the advent of long-distance rail in Ontario, wharves decreased in importance.

By the 1850s, rail was king, and the first of a series of infill projects was proposed. The Esplanade created additional land south of Front Street, and the project was underwritten by the railways. The Ontario Brewery, owned by Cayley and Nash and built in 1847 out over the water on caissons across from the bottom of York Street, was a casualty of this necessary expansion of the city. In its place now stands Union Station.

Over the course of subsequent decades, additional infill took place under the authority of the Toronto Harbour Commission. The city literally grew into the lake, leaving Fort York, which had been subject to naval bombardment, five hundred meters inland. The infill process goes some way to explaining why so many breweries had chosen Front or King Streets as their location. At one time, they were handy for the wharves.

Introduction

The Rivers

With the amount of harbour infill that took place, it became necessary to do something about Toronto's many creeks. In addition to the fact that the creeks' courses had been extended, the rapid growth of population meant that they were becoming polluted. The situation became so bad that there was a moratorium put on cutting ice out of Ashbridges Bay. As a result, many of the creeks were adapted into Toronto's sewer system in the late nineteenth century.

For breweries, this was a mixed blessing. Many of the earliest breweries had been purpose built next to creeks or rivers. Garrison Creek, Taddle Creek and Castle Frank Brook were all waterways that provided desirable locations. Water is the key ingredient in beer, but before the widespread use of steam engines or electricity, it was also used to power mills. Rapid technological advancement negated the need for these rivers, and they were buried.

The advent of a sewer system was a mixed blessing. For one thing, municipal water was expensive for breweries to purchase. For another, the initial foray into sewer construction was as inadequate as it was time consuming. City council meetings from the 1870s are littered with mentions of brewers requesting improvements to a system that was beleaguered out of the gate.

The Streets

Because the initial layout of the city of Toronto was based on Ontario's concession system, the streets of the city follow a grid template with some minor deviations. Sections originally made up of one thousand acres were divided into usable urban lots, with streets added for access between main thoroughfares. Those lots were then subdivided, and additional side streets were added to make smaller properties accessible.

Some streets that exist now, like Bay and Dundas, are made up of several smaller streets that were joined together as an afterthought. Many streets have simply been renamed: Sherbourne was once Caroline, Adelaide was once Newgate, Richmond was once Duchess and so on. When referring to the location of breweries within this book, I will try to provide both in order to create the context of a rapidly changing Victorian city.

Introduction

The Population

Toronto's population expanded very rapidly throughout the nineteenth century. The majority of the growth in the first half of the century is related to European immigration. The single largest source of immigrants was Ireland, with many fleeing the Great Famine in the late 1840s. They became the largest ethnic group in the city, and the Protestant Irish replaced the Family Compact as the dominant social power.

Table I. Population of Toronto, 1812–1911

1812	700
1834	9,000
1840	16,000
1851	30,775
1861	44,821
1871	46,100
1881	86,400
1891	181,200
1901	208,000
1911	376,900

A population chart will hopefully illustrate the rapid growth, although it should be viewed with the understanding that the population reported is from an increasingly larger geographic area. Small towns close to Toronto were annexed to the growing city throughout the 1880s and 1890s. The growth at the turn of the twentieth century also represents a generational shift of rural population towards the urban centre and of migratory workers settling within the city.

Introduction

THE TAVERNS AND LICENSES

Throughout the nineteenth century in Toronto, the use of alcohol was a great deal more widespread than it is today. As W.H. Pearson noted in his *Recollections and Records of Toronto of Old*, the temperance movement had little luck in quelling the consumption of alcohol, but it was able eventually to limit the number of places in which it could be purchased. The chart here, sourced from Pearson's text, will help illustrate that impact.

TABLE II. TORONTO TAVERN LICENSES, 1837–1911

Year	Taverns	Population	Population per Tavern
1837	76	9,652	127
1865	300	45,000	150
1874	309	68,000	220
1911	110	376,900	3,426

This was truly temperance on the march, especially when you recall that the 110 taverns listed in 1911 is representative of all of the downtown core and all of the small towns that had been annexed to make up Toronto. Propriety had become the watchword to the extent that it changed the culture around Toronto's taverns. Before 1907, it was custom for publicans to disperse complimentary flasks of whiskey to their customers on Christmas and New Year's Day. In 1907, the decision was made to put the money that had previously been used for that purpose towards charitable donations.

Licensing was an important consideration for large brewers in Toronto at the end of the nineteenth century. With a limited number of sales outlets, tied houses became very common. Breweries would stand publicans the balance of their mortgages, the unspoken agreement being that only that brewery's beer would be served on the premises. It was a universal practice, although the terms were far more beneficial for the brewer than the publican.

Since there were so few new licenses being issued, the value of a license in a single hotel climbed precipitously. All told, the members of the Toronto Brewers' Association had sunk $360,000 into seventy-eight hotels in 1907. By 1914, individual hotel licenses were changing hands for upwards of $50,000, and a shop license to sell alcoholic beverages sold for $38,000. This was a ridiculous amount of money to pay for a license on the eve of prohibition.

Chapter 1

TORONTO'S FIRST BREWERIES, 1800–1853

One question that surrounds brewing in early Toronto is who was responsible for brewing the first beer in the city. One possibility that is brought up periodically is that the soldiery would have been brewing for its own purposes long in advance of a commercially established brewery.

Prior to British settlement of York, there was a minor French outpost called Fort Rouillé, which occupied a position on the lakeshore on what has become the grounds of the Canadian National Exhibition. Fort Rouillé was more trading post than significant military presence. It existed from 1750 to 1759, and the outline of the wooden palisade is visible to this day. It is a natural supposition that such an outpost would have brewed its own spruce beer, although there is no record of that production.

The record that exists suggests that Abbé Picquet, while passing through the territory in 1752, "found good bread and good wine" and that the fort was better equipped than others in the region. Given the small complement of men stationed at Fort Rouillé (eight, doubling to sixteen in wartime), it is likely that they were supplied with wine and brandy from Fort Frontenac at the end of Lake Ontario. They would have had no need to produce their own beer, although they did have the wherewithal to do so.

Fort York, farther along the shoreline to the east, also seems at first glance as though it could have been a candidate for the first brewery in Toronto. Although Fort York was established in 1793, the garrison itself was quite small up until 1800 because tensions that had led to the relocation of the capital had relaxed. The vaults and wine cellar are still on display, but there

LOST BREWERIES OF TORONTO

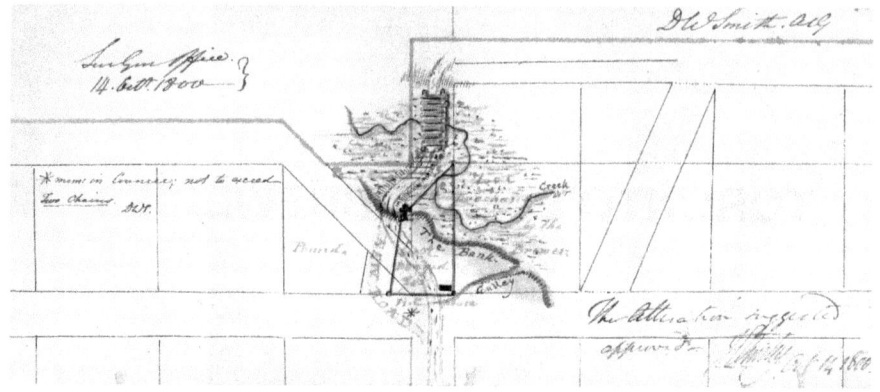

This sketch of an irregular lot being sought for the Henderson brewery at York dates to 1800 and suggests that the brewery would have been up and running the following year (although conservative estimates date it to 1802). *Toronto Public Library.*

is little evidence for brewing beer in the quantity needed to fulfill the rations. In the earliest days of Fort York, it is likely that beer was shipped in from Kingston or that the ration was replaced with rum.

The earliest records of a commercial brewery in Toronto begin at the planning stage and display the nature of the town of York as a construct. Reverend John Stuart wrote in 1801, "The town is a Hot Bed, where every thing is forced, unnaturally, by English money. I know of no Trade now existing, or to be expected at any future Period, to support or enrich it." Stuart clearly considered York a byproduct of the presence of the fort.

As an example, he provided a "recent fact…[a] Brewer from Kingston removed to York lately and, on application to the Governor, obtained one of the King's vessels to transport wheat and other Grain from Kingston and the Bay of Quinte, before beer could be made." The brewer whose tribulation he related was Robert Henderson.

The earliest record of Robert Henderson's brewery is from 1800, and it is a planning request drafted by Sir David William Smith, one of the most trusted of John Graves Simcoe's subordinate officers. The layout of the streets was not complete at this point, and an irregular lot at the northeast corner of Sherbourne and Richmond abutted the land that Henderson had purchased. Making up about half an acre, it was useful for the additional access it provided to Taddle Creek.

Henderson's operation was not large. Taddle Creek powered a milling plant, but the brewing water came from wells. He was able to produce thirty barrels per week, which we know from an advertisement in the

Upper Canada Gazette from 1809. With an operation of that size, he would have been brewing from late October to May, depending on the weather each year. A conservative estimate for his annual output would be 1,500 hectoliters per year.

There is some confusion in the historical record as to the date of the foundation of the second brewery, but the location is certain: it was directly across the street. George and Joseph Shaw may have opened their brewery as early as 1807 at the southeast corner of Sherbourne and Richmond.

On April 13, 1811, Robert Henderson married Elizabeth Hunter, the daughter of William Hunter, who was a blacksmith and veterinary surgeon for Governor Simcoe. Unfortunately, Robert Henderson would not live to see the first anniversary of the marriage. His untimely passing led Elizabeth to marry William Shaw, brother to George and Joseph. The brewery on the southeast corner was run by the Shaw brothers from 1812 to 1818, but it is possible that Henderson's brewery was being run at the same time by Dr. Thomas Stoyell, a non-practicing medical doctor who had emigrated from the United States.

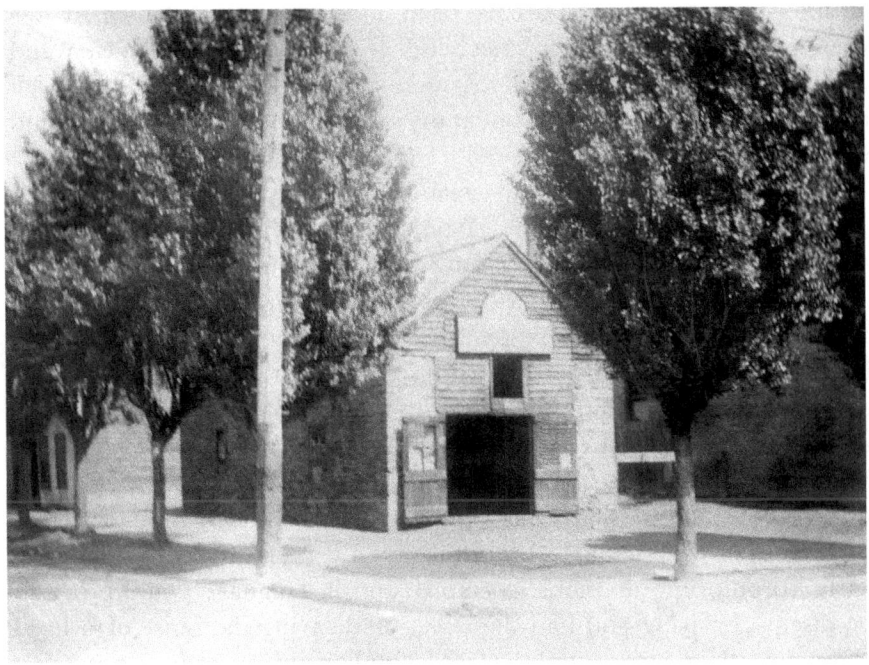

This blacksmith's shop was the last surviving building related to Toronto's first brewery. At the time the photo was taken, it was being used as a storage shed for the much larger Walz Brewery, whose chimney can be seen in the background. *Toronto Public Library.*

Stoyell arrived in Toronto in 1799 and for a period of six years between 1806 and 1812 ran Toronto's first tavern, which had been erected by Abner Miles and Ely Playter. The location of Playter's tavern at the corner of King and Sherbourne, two blocks from the locations of the breweries, guaranteed that Stoyell would have been on friendly terms with the brewers. As an expatriate American, he abandoned the tavern that he owned during the War of 1812.

By 1818, Thomas Stoyell had purchased the Shaw brewery on the southeast corner of the intersection in a partnership with John Molloy and John Doel. Little is known of Molloy, but Doel would become a brewer in his own right at the dissolution of the partnership in 1822. The same year, Stoyell married Rhoda Matthews and made the move north to Churchville, Ontario. He passed away in 1832 at the age of seventy-one, bequeathing the entirety of his estate to the Methodist Conference.

That such a donation should have come from a producer and seller of beer who had also been a Methodist steward illustrates important points about the morality of York in the early days of the century. For one thing, beer was not really viewed as an intoxicating beverage, despite all indications that it would have been above 7 percent alcohol. It was viewed as a manufactured product necessary to the function of society and compartmentalized from moral strictures except in excess. There may well have been teetotalers in York, but at the same time, the Bishop of Toronto was having barrels of ale delivered.

The Sherbourne Brewery, which occupied the southeast corner, would change hands a number of times before it met its demise by fire in 1856. The year 1833 saw John Scott operating the brewery briefly before selling it to his brother-in-law, John Lynch. Lynch operated the Sherbourne Brewery for six years before moving to Brampton to go into a new brewery partnership with Scott. Lynch became a thoroughly respected citizen, holding the office of reeve and gaining a number of awards as an essayist. In his pamphlet *Canada: Its Progress and Its Prospects*, he forecast the shift to large industrial brewing that would take place in the 1870s and, perhaps more importantly, illustrated a fundamental problem that would affect Toronto nearly a century and a half later. In early Toronto, the divisions in culture and in language could prove to be disenfranchising and had the effect of delaying the sense of a local character: "It is surprising how few Canadians we meet in society; you may, in this town, go into company where you will meet a large number of young people who never in their lives have been a hundred miles from

Brampton, but who, on enquiry will be found to be all English, Irish or Scotch, not one Canadian."

Cultural amalgamation may have been difficult, but Toronto was a fairly progressive place. In the 1850s, the Sherbourne Brewery's ranks produced the first female brewer in Toronto's history. Richard Jewell and Jane Luke Jewell had come to Canada from near St. Austell in Cornwall. Jane's elder brother, Joseph, worked with them for a short time before founding a brewery of his own in Tillsonburg. Richard passed away in 1848, and Jane ran the brewery until 1853.

Chapter 2
JOHN DOEL'S BREWERY, 1827-1847

Perhaps the least important thing about John Doel was the fact that he owned and operated a brewery in Toronto for a decade on either side of the Rebellion. He hailed originally from Wiltshire in England, close to the Somerset border. He married in 1815 and emigrated from England to Philadelphia in 1817 before settling in York in November 1818. By the time John Doel had entered into partnership with Dr. Thomas Stoyell in 1818, he was already twenty-eight years of age.

You would be forgiven for thinking that a brewer's first course of action upon landing in a new town would be to slake his thirst. The historical record suggests that Doel and his wife, Hannah, arrived in time for the first service in the first Methodist church in Toronto, located at the corner of Jordan and King. Previously, services had been held in Dr. Stoyell's home on King Street East. Given Stoyell's long tenure in Canada, it seems unlikely that their partnership in brewing had been prearranged. The two must have gotten along immediately to begin their brewing partnership during the dying days of that year.

Following the dissolution of their enterprise in 1822, Doel worked temporarily in the role of Toronto's postman, and although he carried on in that line until the 1830s, he had established a brewery of his own by 1827. His home was at the northwest corner of Bay and Adelaide, and the brewery was behind the house along Bay Street. According to Dr. Henry Scadding, Doel produced beer that enjoyed "good repute in the town and neighbourhood."

LOST BREWERIES OF TORONTO

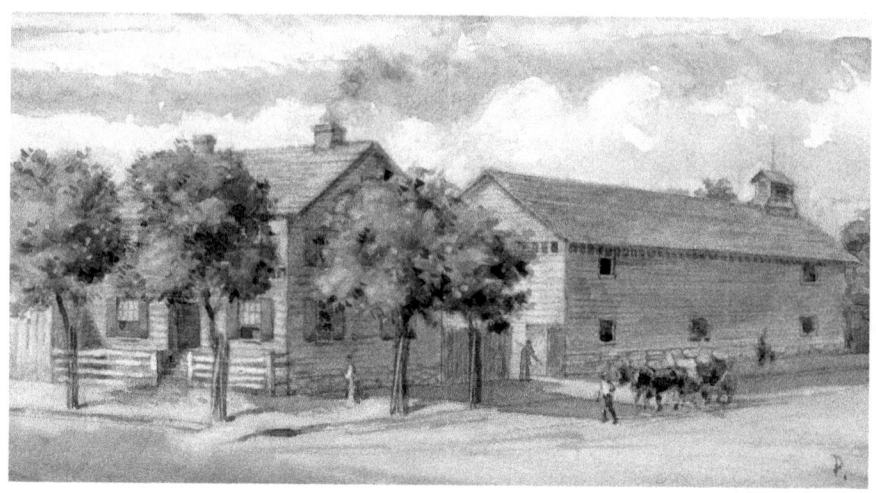

Pictured here is John Doel's home and brewery. The view is from the southeast corner of Bay and Adelaide, with the brewery fronting on Bay Street. The brewery burned down in 1847, but Doel's home remained at that corner until the twentieth century. *Toronto Public Library.*

Doel represents the beginning of a period of transference of power in early Toronto. There is the small personal hypocrisy of manufacturing alcohol while being a founding member of the Methodist church, which counseled temperance and did not allow alcohol on its premises. It is in some ways a question of exploiting sin to promote virtue—of borrowing from one Toronto to build another. Doel's tithes as a member of the congregation would have assisted in building Toronto's first Temperance Hall on lands donated by Jesse Ketchum, fellow congregant. Naturally, it was located on Temperance Street.

In a more immediate sense, Doel's brief sojourn in Philadelphia seems to have influenced his political opinions. He would become a lifelong proponent of reform in Toronto. By the time of his arrival in 1818, York was still very much a planned economy operating under the auspices of the British Empire. Due to ongoing reform in England and York's small size, it was effectively more conservative than England itself. Election results in the late 1820s bounced control back and forth between Conservatives and Reformers over questions as simple as whether a chancery court could be established for the purpose of equitably settling legal disputes. The institution of Responsible Government was not on the table.

Owning a brewery was an excellent way to foment change within society. An allowance for beer money to the soldiery at Fort York meant that your

coffers would never run dry and the profits would stay within the city. If that money could be used to finance Sunday schools and meeting halls for new immigrants disenfranchised from the Anglican Church, then so much the better. It assisted in creating a community that spoke for the less powerful in society, using the tastes of the establishment to bring about the reforms that would be needed.

The Declaration of the Reformers was signed at Doel's brewery in August 1837. Doel did not himself believe in armed insurrection, but such was not called for in the Declaration: "The right was conceded to the present United States at the close of a successful revolution, to form a constitution for themselves; and the loyalists, with their descendents and others now peopling this portion of America, are entitled to the same liberty without the shedding of blood—more they do not ask; less they ought not to have."

Despite this, armed insurrection came in December 1837, and many of the meetings of the reformers were held at Doel's Brewery, including one mere days before the Battle of Montgomery's Tavern. Doel and his son were

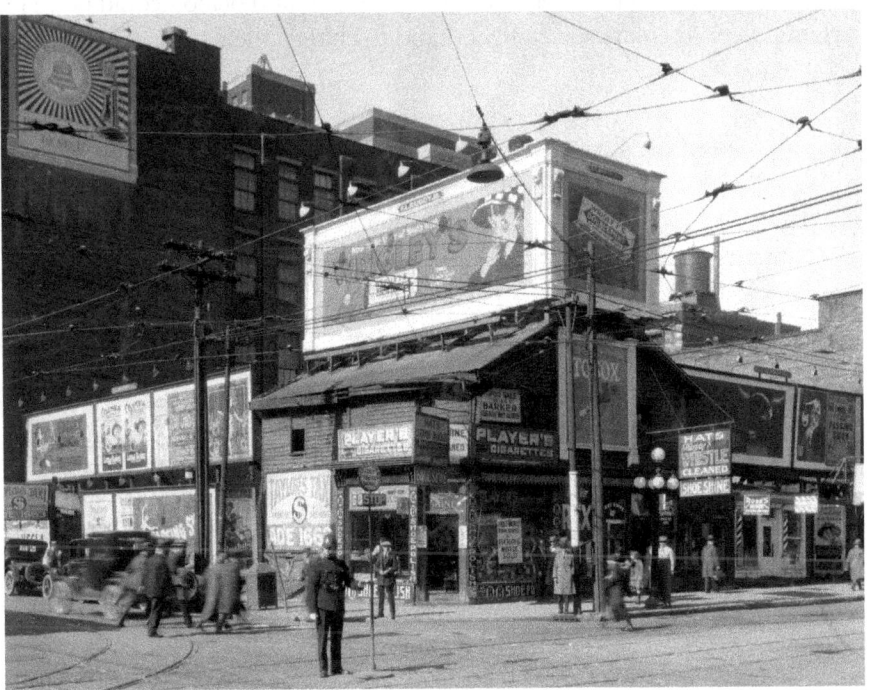

John Doel's home stood until the twentieth century, at which point it had become a fairly run-down store offering shoe shines, hat blocking and Player's Navy Cut Cigarettes. Sometimes progress requires you to get your hat blocked. *Toronto Public Library.*

arrested on no fewer than five occasions. Ultimately, the rebellion failed, and those who took part in it paid the price for their failure. Doel was not amongst them, having chosen not to participate.

His brewery burnt down in the dry summer of 1847, the year before Responsible Government came to Upper Canada. When that development allowed for William Lyon Mackenzie's return, it happened that Doel was the one who had acted as steward for the lands that he had once owned. The return of those lands to Mackenzie (at a very generous price) allowed him the privilege to sit in the legislature. The hotheaded Mackenzie would proceed to alienate all his potential allies and lose faith in the very concept of reform.

In the meantime, Doel and his family had become venerable members of Toronto's society. By the time of his death in 1871, he had been an alderman, a justice of the peace and a trustee at both the Temperance Street Church and Toronto General Hospital. The even-tempered brewer had helped to bring change to the city through gentle guidance and good works, trusting that demography would bring about the change that rebellion could not. He had used beer to create societal good and to change the nature of the city.

Chapter 3
JOHN FARR'S BREWERY, 1820–1888

The main difficulty with living in England at the end of the eighteenth century was that social mobility didn't exist. There were professional classes, but that was a lateral move for lesser gentry. If you were a farmer, there were very few options. With Enclosure Acts restricting the amount of arable land for farmers and a population boom occurring, immigration to the New World was a sensible and attractive choice.

In the case of Elisha Farr's family, several of the children chose to leave England, but not before learning their trades. Elisha was a tenant farmer in the town of Weston in Hertfordshire. By the time his children were born, the landlord of his farm was John Pryor. Elisha Farr had cattle, but the farmland was used primarily for producing barley, which he sold to his landlord. Pryor was responsible for a maltings and brewery in nearby Baldock, a town that held the reputation at the time for producing some of the best malt in England.

James and John Farr were brothers who came to Upper Canada in the second decade of the nineteenth century. James Farr, the younger of the two, settled on the Humber River and took over a mill in 1815. A prominent member of the community, he named the town Weston after his birthplace. In addition to the mill, James Farr owned 150 acres, which he sold in parcels to farmers in a neatly symbiotic relationship. They would clear the land and grow grains that he would then mill for a fee.

John Farr, the elder brother, was a later arrival in Canada. In 1820, he petitioned the government for the right to found a brewery on Garrison

Creek, barely half a mile north of Fort York, on Lot Street. James Farr owned his mill until 1828, creating a vertically integrated enterprise shared in by the brothers and modelled on the system they had grown up participating in. The difference was that in Upper Canada, they would see the benefit of their work.

The initial land prospecting created a system where James and John Farr profited from every step that went towards making beer: the land for the farmers, the seed for their farms and the sale of the grain from miller to brewer at a rate low enough to take the sting out of paid duties and make a pint of beer even more profitable given a captive military audience on their doorstep.

We know comparatively little of James Farr, but John Ross Robertson preserved John's memory thusly: "Mr. Farr, the proprietor of the brewery, a North of England man in aspect as well as in staidness and shrewdness of character. His spare form and slightly crippled gait were everywhere familiarly recognized." The brewery itself was located at the bottom of the ravine that housed Garrison Creek. It was demolished in 1888, but at the time when it stood as one of the only buildings on Queen Street west of Spadina, it could have been described as "long, low and dingy-looking." It was constructed of hewn logs, initially covered in clapboard but eventually covered in brick.

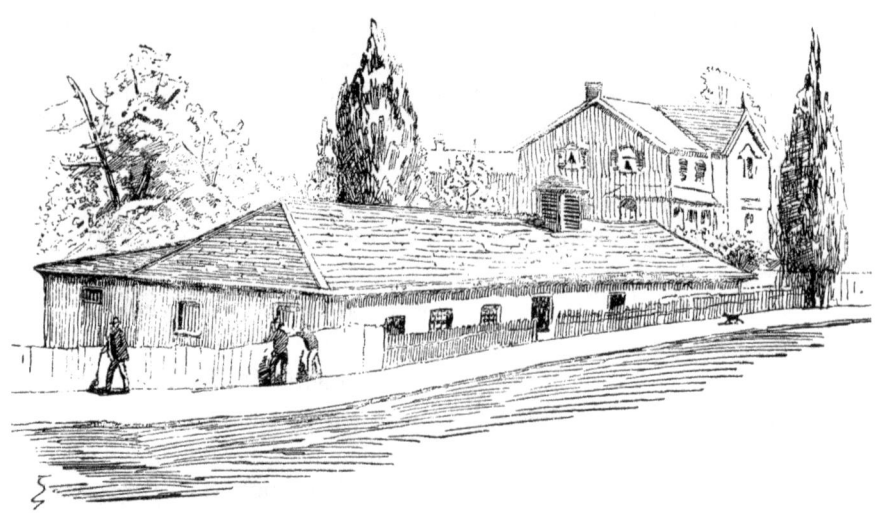

From Queen Street, the Farr Brewery didn't look like much of an operation. *From John Ross Robertson's* Landmarks of Toronto.

Lost Breweries of Toronto

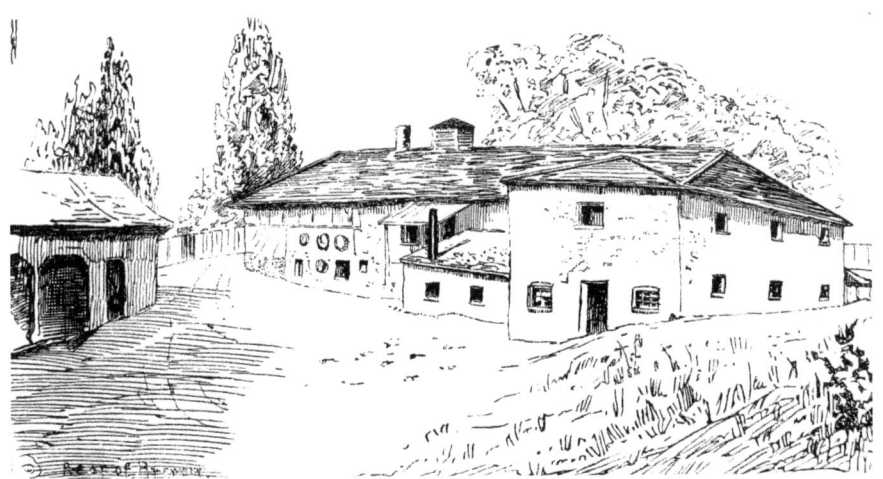

From the rear, John Farr's brewery was a far more impressive operation, housing stables (pictured left) and a two-storey malt house and brewery. Compared to even the Cosgrave Brewery across the Garrison Creek, it was diminutive, which may account for its 1888 closure. *From John Ross Robertson's* Landmarks of Toronto.

Additionally, Robertson recorded some details about brewing at Farr's that jibe with other accounts from the time: "In the early days drinking was a more common habit than now, and old brewers say that the beer was better than that of the present time. There was no duty to pay. Barley was cheaper, being worth from thirty to forty shillings a bushel, and as a result the brewers put more malt in the beer. The wholesale price at the breweries was a shilling a gallon. The retail price was two pence a glass." Even more impressively, the Farr brothers managed a place to sell the beer. By the 1830s, James Farr was the proprietor of the Peacock Inn at Dundas and Weston Road in the Junction neighbourhood.

Given the social mobility the Farr brothers were suddenly experiencing, something that could not have happened in England itself, it's unsurprising that they were politically on the side of reform. Meetings of the rebels are reputed to have happened at the brewery. Unlike John Doel, the Farr brothers would become involved in the rebellion. James Farr is alleged to have taken part in William Lyon Mackenzie's robbery of the mail stage outside the Peacock Inn, helping to fund Mackenzie's flight to the United States.

Although James Farr passed away in 1845, the Peacock Inn was operated by his family until 1875. John Farr continued brewing in Toronto until 1856, though seemingly entering into a hiatus between 1835 and 1847, as lessees

ran the brewery. Upon his resumption of brewing in 1847, he built a house that stands as his legacy in Toronto to this day. John Farr's house at 905 Queen Street West is an attractive Georgian brick construction set back from the street, exemplary of the type of home middle-class professionals built for themselves in the early days of Toronto. Both John and James Farr had risen from being tenant farmers without prospects to well-to-do professionals who had provided for their children in a single generation.

Farr's Brewery tells the story of the social mobility that was possible after immigration to Canada, but the story does not end with the Farr brothers. When Farr returned from his hiatus in 1847, he took on a younger brewer who had learned his trade in Cobourg, Ontario. John Moss, originally from near Belfast in Northern Ireland, would also experience the benefits that Toronto's brewing trade could provide to a savvy businessman. At Farr's retirement, Moss went into partnership with John Wallis.

The generation of wealth that brewing offered meant that Wallis could indulge his political aspirations, becoming alderman for St. Patrick's Ward in Toronto for several years in the 1860s prior to becoming the first MPP

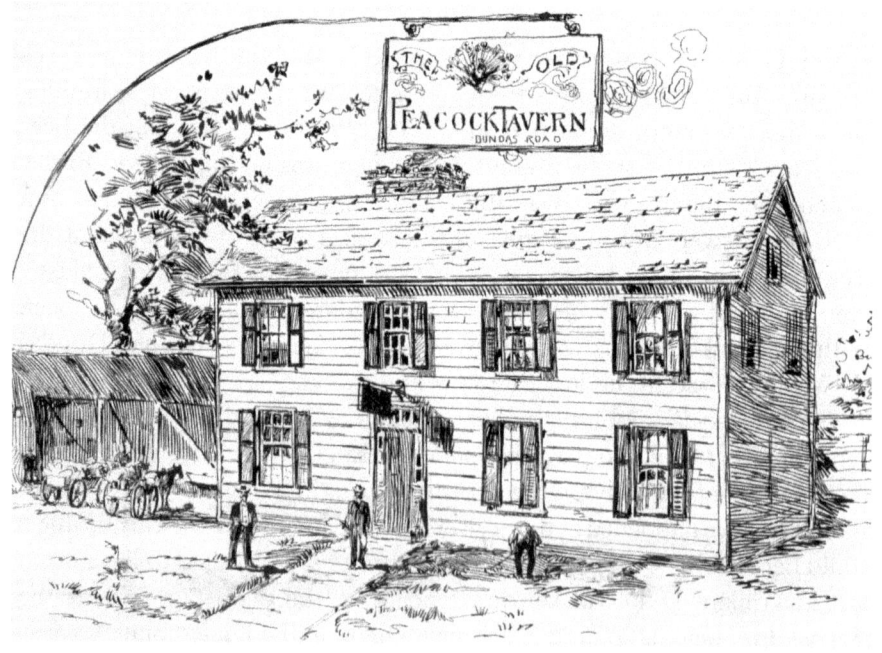

The Peacock Tavern was owned by James Farr and was located at the corner of Dundas and Weston road. It was the site of a stagecoach robbery in 1837 in which James Farr may have been involved. It was left to his wife and children upon his death, with John Farr acting as executor of the estate. *Toronto Public Library.*

LOST BREWERIES OF TORONTO

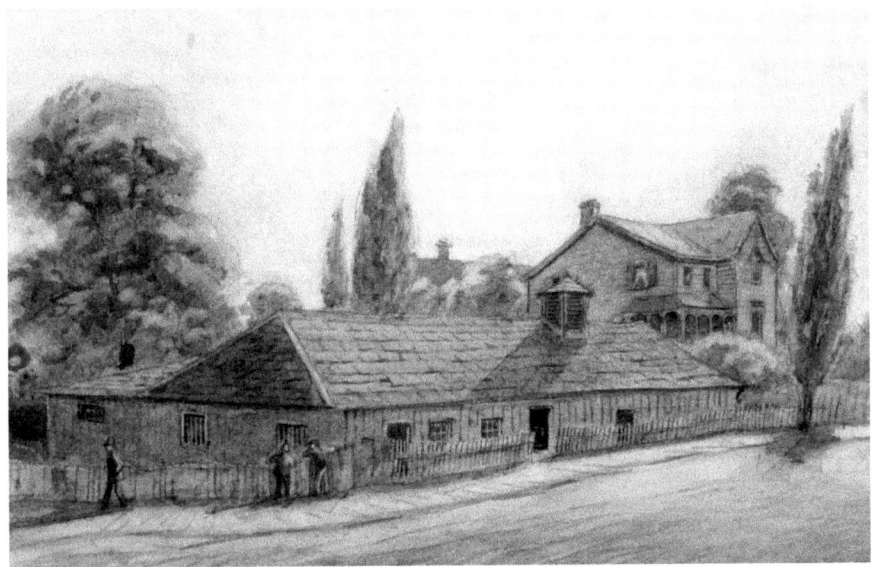

John Farr's brewery occupied some of the space in the ravine next to Garrison Creek. This view, facing south from the north side of Queen Street, displays the second-floor entrance, which was developed when streetcars began to run along the route. *Toronto Public Library.*

for the newly created seat of Toronto West in 1867. John Moss was less ambitious personally, but he used the proceeds from the brewery to raise an impressive brood. The eldest son, Thomas, was educated in the finest schools and would rise to become Chief Justice of Ontario at the age of forty-two. Charles Moss, who worked in the brewery as a young man, would eventually be taken under Thomas's wing and occupy the same judicial role, periodically acting as administrator of the province of Ontario.

The Farr Brewery charts the story of the sheer wealth and influence that could be generated in a rapidly expanding Toronto. Those interested in the brewery shifted over the course of a single generation from active rebels existing as the opposition to a foreign power structure to the arbiters of the nature of power within the province. By the 1880s, at the time of the brewery's demolition, the capacity of the brew house and cellars would have been insufficient to compete with the massive late Victorian structures springing up around town. That was all right. They had done their job.

Chapter 4
THE HELLIWELL BREWERY, 1820–1847

If the Doel and Farr breweries had in common their support for the reform of the political system in York and the direct actions that they took in order to support that reform, then the Helliwell brewery was the polar opposite. There are many reasons for this, but the most important has to do with a small difference in lead time. There was not a great difference in the fortunes of these families in England, but the rapid development of Upper Canada in the early days of the nineteenth century meant that political allegiance could be determined simply by the year that you arrived.

The Helliwells had come from Todmorden in Yorkshire, which was not famed for the quality of its brewing at the time. If anything, Todmorden's production was a mixture of agriculture and weaving, with mills devoted to both industries. By the turn of the nineteenth century, agriculture had become less prominent, and the production of woolen cloth was being supported by the advent of toll roads and a newly completed system of canals. Before the mechanization of the textile industry in Yorkshire, there was a living to be made even if you were not the owner of the mill. With the adoption of that machinery, wages fell so ruinously low that West Yorkshire became a significant site of Luddite revolt, with workers smashing and burning their equipment.

The Helliwells were mill owners, but that status within a rapidly changing society was no guarantor of future success in a country with a booming population. Thomas Helliwell himself had six children by the time the Luddite revolts broke out in 1812. The previous year, his youngest

daughter, Elizabeth, had married a local tinsmith named John Eastwood. Subsequently, they decided to move to Upper Canada. John Eastwood settled in Lundy's Lane and engaged in trade across the river with Buffalo. The letters home must have painted a picture of a land with possibilities that did not exist for even a well-to-do milling family. The Helliwells came to Upper Canada in 1818.

At the time, the area around Lundy's Lane and Niagara had a greater population than the town of York and was a better seat of business for those with a trade. Relations with the United States were once again peaceful, the question of territorial boundaries having been settled. Thomas Helliwell would become a shopkeeper and eventually a distiller in Niagara, realizing that the sale of whiskey was more profitable than the sale of general goods. In those days, whiskey went for one shilling per gallon at York. Helliwell must have been restless with the lack of consuming work. Now fifty years old, he had spent his entire adult life as a miller, and while distilling was certainly a profitable trade, it wasn't likely to provide for his family.

Seeing the possibility of the town of York, the Helliwells and the Eastwoods settled on the Don River to the northeast of the city. John Eastwood named the settlement after their home for the striking resemblance the Don Valley bore to that part of Yorkshire. At the time the Helliwells had a homestead constructed in 1820, they owned a significant tract of land encompassing nearly a quarter of what we think of as East York—almost everything northwest of the intersection of Donlands and the Danforth. At the time, the Don Valley was home to all manner of wild creatures. The sheep the Helliwells kept were dispatched by wolves on their doorstep.

The majority of the picture we have of the Helliwell brewery is due to the fact that the second-youngest son, William, was a dedicated diarist. Taking up pen in 1830 at the age of nineteen, William had been in Upper Canada since the age of seven. He would have been just barely old enough to remember his native Yorkshire, and as a result, he grew up knowing only the society of Upper Canada. His diary provides us with huge amounts of detail societal, professional and personal. It is a unique insight into brewing in the early nineteenth century in North America and into Toronto's development.

By the time William began to keep a diary in November 1830, the Helliwell brewery had become a successful concern. While William was the brewer, the organization of the family interest lay with his older brother Thomas, who had been a successful businessman even prior to leaving Yorkshire. Thomas Helliwell Sr. had passed away in 1823. From the earliest days of the brewery, the Helliwells were exporting beer to the head of the lake at

Lost Breweries of Toronto

The Todmorden Mill still occupies the property owned by the Helliwell family, although the mill itself was built by the Taylor family. The majority of the families in the Don Valley were eventually related by marriage. It was an insular world. *Toronto Public Library.*

Niagara, the relationships they had formed there during their brief sojourn proving invaluable to their interests.

Within Toronto, Thomas Helliwell was the force behind a number of businesses, including tinsmithing, a trade in which his father had entered with John Eastwood and which his younger brother, John Helliwell, now operated. While it was certainly the case that brewing made up a decent part of the family's trade, they were also related by marriage to the Eastwoods and the Skinners in the Don Valley and would, as a result, have commanded a large portion of the production capacity of east Toronto. There were paper mills and gristmills upstream from the brewery.

Taken all together, it seems a natural extension to acquire a wharf for shipping, which the Helliwells did. A successful businessman with a deep understanding of trade in Upper Canada, Thomas Helliwell would become a director of the Bank of Upper Canada in 1834—a greatly desired position for a businessman in a society where a lack of currency in circulation could make doing business difficult. At this point, Thomas would have been living downtown in a house that had originally been built for Dr. Thomas Stoyell. He was clearly regarded as the head of the family.

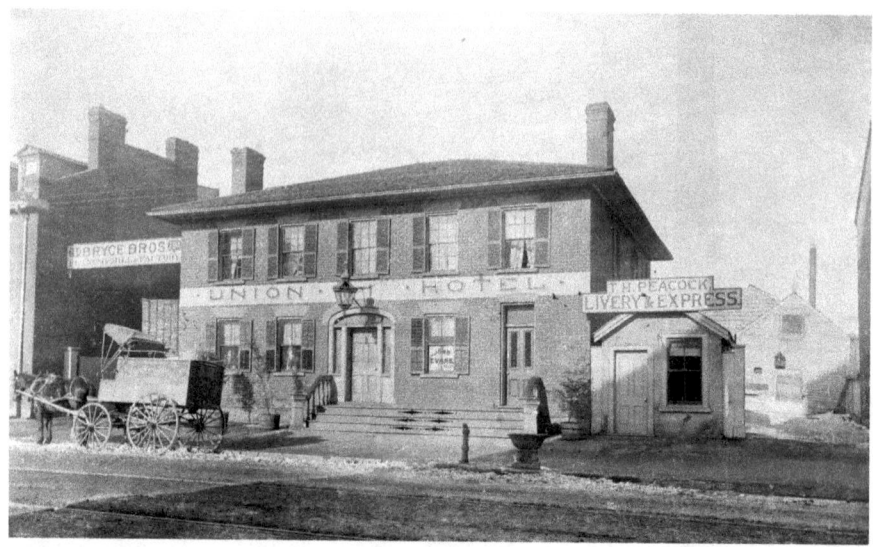

The Union Hotel was also known as Stoyell's Tavern earlier in its existence. It was not purpose built as a tavern, acting as the residence of Dr. Thomas Stoyell and, subsequently, Thomas Helliwell during his tenure with the Bank of Upper Canada. *Toronto Public Library.*

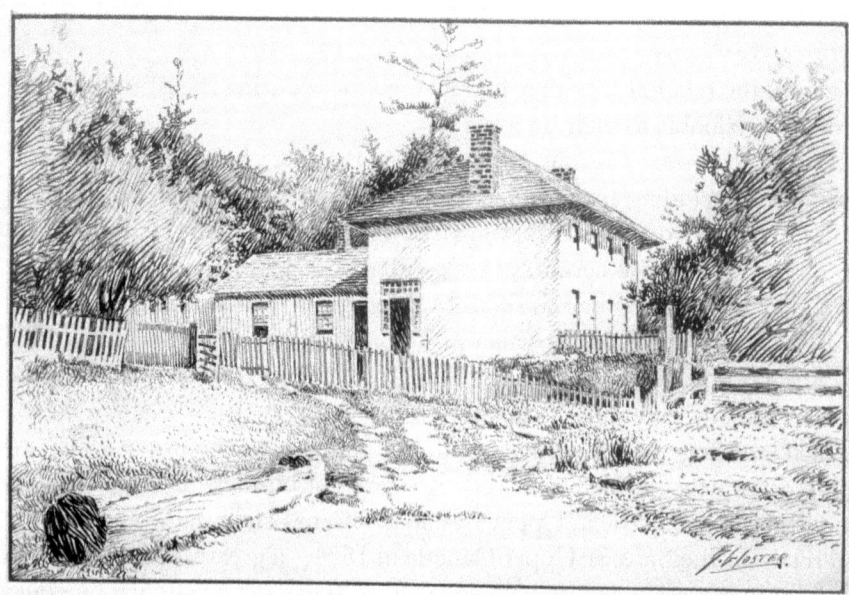

William Helliwell's home still stands near the Todmorden Mill. It is a rare example of adobe brick construction in Toronto, having been constructed long before the Don Valley Brick Works had become an established property. *Toronto Public Library.*

Lost Breweries of Toronto

By the time William began keeping records of his involvement, the brewery had been in operation for a decade. His elder brother Joseph was primarily interested in farming but would watch the homestead while William was away. His younger brother Charles would have been thirteen years old and learning the trade. William, having been brought up as a brewer, was endlessly interested in the specifics of running the brewery, frequently making notes in his diary about the amount of extract in a batch of wort or about the scheduling that took place from day to day.

The brewery would operate from about early November to late May. During the season, William would mash in slightly before dawn, expressing consternation when he would miss his mark. The brewery had its own maltings, and loads of barley had to be brought in so that beer could be made, a task frequently made difficult by the nature of the river valley. It is not for nothing that the most frequent observation in the diary is "roads very muddy." The maltings were carried on separately from the brewery, overseen by other employees.

The brewery would have used six-row malt, the main variety that was grown in Ontario before the twentieth century. The hops would have been either a native variant like Cluster or Goldings, depending on whether English hops were available. In later years, the Helliwells would plant a significant hop yard. While we have little idea of the yield that the hops might have provided in the Don Valley, we can estimate the size of the yard itself from the number of poles used for trellises. In 1834, it would have been nearly 450 poles, meaning that the footprint of the hop yard would be nearly ten acres at a conservative estimate.

We know from his mention of a visit to the manufacturer while he was in London, England, that William Helliwell was using a particular scale of measurement for his wort. It was a Dring and Fage saccharometer of the kind that was widely used in England. Rather than specific gravity, the saccharometer measured pounds of extract per barrel of liquid.

The measurement, referred to as beer gravity, tells us that he was producing finished wort at about thirty-three pounds of extract per barrel. In modern terms, that is an original gravity of approximately 1.090. Assuming a yeast strain capable of the output, William Helliwell's beer could have been between 8.5 and 10.0 percent alcohol. This was not very much stronger than average at the time. For the Loyalists who were used to the wheat wines of upstate New York, it would have been ideal.

By the brewing season of 1830, the Helliwell brewery would have been producing about ninety barrels of beer per week, or about three thousand

barrels of beer per year. For context, the Helliwell's operation would have been larger than many small breweries in Ontario today. The ale would have been fermented in a number of tuns, with conditioning taking place in individual barrels or puncheons.

What was not ideal was the location of the brewery. The Don River may not look very impressive in terms of its flow, but during a particularly hard thaw, the risen waterway could prove destructive. March 1831 was just such a season. Not only had the drainage for the maltings backed up into the malting floor, but it also swept one hundred bushels of malt away. The entry for the next morning reads, "All the forenoon we spent all hands in getting the mud and malt off the floor and putting it into the mash tub and washing it. The river continued to raise all day and presented a spectacle truley sublime to see. The trunks of trees and flaiks of ice passing down the rappid corrant it took the mill dam away and most of the fence that borderd on the river."

The power of the mills along the river to drive industry was severely compromised. The stillions that held the fermenters in the cellar were waterlogged. The yeast (or what remained of it) would not survive the summer, and replacement would have to be sought from John Farr at the other end of York. Transporting barrels downstream for sale was no longer realistically possible. At the age of twenty, William Helliwell found himself in charge of a brewery that required significant improvements due to the sudden violence of the river.

Yet William Helliwell was up to it. Having come from the professional classes in England, he was possessed of a work ethic, and even at nineteen years old, he was something of an autodidact. There was a duality to his nature. In many ways, he was the consummate professional; one of his first journal entries has to do with borrowing a treatise on the methods of gauging and measurement. He attended the Mechanic's Institute in York for physics lectures on fulcrums and levers and spent much of his spare time in the study of trigonometry and algebra. The notes that he kept are detailed enough that nearly two hundred years later, we're able to reconstruct details about his brew house efficiencies.

At the same time, William Helliwell was something of a Romantic. When not improving his ability in mathematics, he was a great one for poetry, leafing through the works of Byron. He was caught up not only in poetry but also in the cult of hero worship on which English nationalism built its empire. He read Robert Southey's *Life of Nelson* and would put off work to cheer John Colborne's arrival in York. Colborne had, after all, become one

of the heroes of the Battle of Waterloo by flanking and routing the chasseurs of Napoleon's Imperial Guard.

This combination of life as a privileged child and a nostalgia for a world that he had never really known led to a kind of sweet naïveté about matters political. William Helliwell was directly involved in two of the most important events in political life in Toronto in the 1830s. On January 2, 1832, William was present at the Red Lion Inn for a local election but was apparently unaware that it was also to be the by-election that would return William Lyon Mackenzie to power: "[W]hen I got there I found a great assemblage of People and Ensigns flying and Bag pipes playing I was very soon surprised with the People shouting with caps off and completely at a loss to account for it but I was not kept long in suspense for presently a large slay drawn by four Horses and having a frame fixed on it to support a second floor crowded with people made its appearance amid roars that would deafen a person. MacKenzie here began his harangue but my attention was called off to the town meeting."

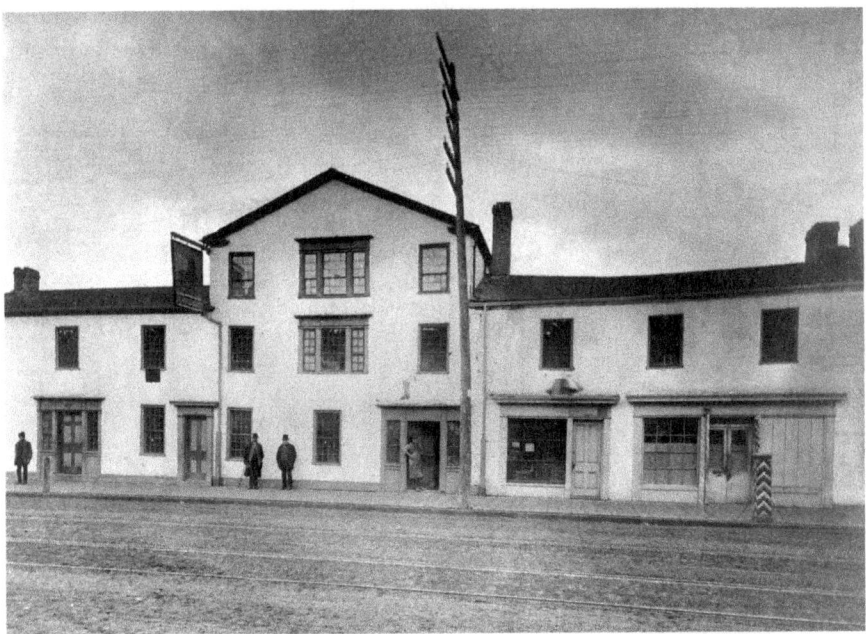

The Red Lion Inn was situated on Yonge Street and acted as the centre of Yorkville, being the site for dances, elections and banquets. It stood through the greater part of the nineteenth century, eventually being torn down to make way for Britnell Books. It is now a Starbucks. *Toronto Public Library.*

William Helliwell was voted path master of the road that ran near his brewery at the town's election, but the real excitement of the evening was Mackenzie, of whom Helliwell did not think highly:

> *I left the meeting and went out to hear McKenzie hold forth. He was reading a pamphlet containing all the grievances or imaginary grievances that he could cull from all the acts of the assembly for the last five years. He made very severe remarks on his Excellency Jude Robinson, Arch Deacon Strachan and others. He likewise gave us an account of his being expelled the Bank the Agriculture Society and the House of Assembly with an account of the ship wreck of the waterloo steamer on the Saint Lawrence where he was very near being expelled from the World altogether.*

Mackenzie won reelection that night at a margin of 119 to 1 by casting himself as the martyr of Upper Canada's liberty, although William Helliwell was almost certainly right to doubt the veracity of all his statements. He also summed up the tone of the evening: "Young Street from the Red Lion to York was full of people and slays and every slay was full and all roaring out hurrah for MacKenzie." While Mackenzie would find himself expelled from the assembly again five days later, his popularity was established.

The Red Lion Inn in winter illustrates an important point about the manner in which people travelled in Victorian Toronto. Sleighing was not only an important means of transportation but also a favored recreational activity in the city's valleys and along its shorelines. *Toronto Public Library.*

Lost Breweries of Toronto

William Helliwell did not pay much attention to the politics transpiring under his nose because the road he had been named path master of ran by the Bright family's home. Their daughter, Elisabeth (Betsey, informally), was the object of his affection and was the subject of a lengthy courtship. Unfortunately, she was to be married to an older gentleman named John Elliot. William behaved in the manner that can only be affected by a provincial lovesick twenty-year-old who has made a point of reading Byron. His attentions, from the point of view of a modern audience, were upsettingly obsessive. The persistent declarations of affection are available to read in the diaries, as all of the notes that passed between William and Betsey were copied by hand into his journal. The less said about the poetry the better.

Betsey Bright finally acceded to marriage with William Helliwell just prior to a scheduled trip to England. There were no breweries much larger than the Helliwell Brewery in York, and in order to learn more about his trade, William Helliwell would have to travel. He did this with some regularity anyway, having visited Peter Robinson in Newmarket when opportunity presented itself and Joseph Bloore almost daily on his way to York on foot.

The journey would take him through New York State and on to London, England, to his family's home of Todmorden. At nearly every stop, he would engage his observational skills on inspecting the local breweries. There was Nathan Lyman's on Water Street in Rochester and Fiddler and Taylor's in Albany. William was skeptical of the twenty-thousand-barrels-per-year production claim. At Boyd's brewery, he noted that three kilns was almost certainly too many for the amount of malt the floors could produce. When not occupied in that pursuit, he would read Alexander Pope's translation of the *Iliad*.

In London, he toured the Nine Elms Brewery in Wandsworth (site of the London Beer Flood of 1814) with the brewer. In his tour of Barclay Perkins, he noted the vast cellar and improved method of steam cleaning the casks. His tour of Calvert and Company takes up several pages, but a brief description of the Porter Brewery highlights the difference between brewing in England in 1832 and his own setup in York:

> *The first place he took me to was the Mash tub which is about 30 feet in diameter and eight feet deep They had just stopped the machine. There was 120 quarters or 960 Bushels of malt in the tub. The underback is about 15 feet square and 6 feet deep cast iron. One of the coppers holds 1200 Barrels and has a machine drove by steam to rouse it and keep the hops from*

settling to the bottom. The other copper is not quite so large. The Hop back is about 30 feet by 15 & 5 feet deep all cast metal false bottom and all. There is a reservoir for water on the top of the House as large as a quarter acre field all Iron.

The tour was a success, and after visiting his extended family at Todmorden, William Helliwell returned to York by way of Liverpool. He put his observational skills to good use and was brewing Porter in addition to ale in very short order. Brewing in York was physically demanding work, and one needed to be physically brave in order to do it. While injuries were commonplace, some required incredible toughness to endure. Lest you think William Helliwell a dandy for favouring Romantic poetry, it is important to relate that he was no physical coward. This is evinced by his self-treatment during a particularly nasty accident:

Commenced Brewing!!! But alas I was not destined to finish. About one o'clock when I was about to start the worts from the copper and had just put the fire together for the purpose of letting burn out before emptying the copper I had only just turned my back when the bottom of the copper gave way and out rushed the Boiling Wort and struck me on the back of the legs and knocked me down. But fortunately I had the good fortune to fall on some wood which kept me out of the boiling fluid which covered the floor. I retreated as soon as possible into the Granary and pulled off my pantaloons and shoes and hose and with them the skin off my legs and ankles. In this state I came through the window by the Mill and round to the House where as soon as possible was applied Linseed Oil and lime water and continued till about six oclock. I began to be faint and was taken to bed and a doctor sent for who when he came said that they could not have been better taken care of.

Although he lay incapacitated for sixteen days, it would not deter him from following his calling.

The Rebellion of 1837 would make him prove his bravery once again. Unlike today, news in Upper Canada in 1837 travelled as fast as people. It is easy to look back on the 1837 rebellion dismissively now, given that it came to a single volley of gunfire in Yorkville. At the time, no one knew that would be the case. No one knew how many rebels there were. No one knew exactly how they were deployed. The uncertainty was enough to close the majority of businesses in Toronto. The Helliwell Brewery was especially

vulnerable, as it possessed one of the only bridges across the Don River and was therefore of strategic importance.

On December 5, 1837, William Helliwell found himself returning from Niagara on a collection tour. He hurried home as quickly as possible. While Betsey had not been left alone entirely, she was nine months pregnant at the time and was unable to travel even the short distance to Toronto. No doctor would make the journey to the brewery. In another circumstance, one might simply have burnt the bridge and retreated to the city. As it stood, the brewery employees kept guard, and William Helliwell would brave the uncertainty of the Don Valley to be sworn in as a special constable.

On December 7, William found himself at the Parliament Building to acquire shot and a musket and ended up being made impromptu quartermaster in charge of powder and shot for the government of Upper Canada. Over the course of the next two days, he cast nearly two thousand rifle balls to arm the loyal citizens of Toronto.

By December 9, two thousand rebels had been captured. By the eleventh, one thousand troops had arrived from Cobourg. By the thirteenth, William Helliwell was finally able to move his wife to her parents' house at the east side of the Don River Bridge. On the fourteenth, he was once again a father.

The Helliwell Brewery burnt in 1847, and William Helliwell would give up his career as a brewer to become a miller near Highland Creek in Scarborough. It is possible that his heart was no longer in his work. Betsey had passed away in the early 1840s. He would live until the age of eighty-six and keep a diary until the end of his life. Whereas we know comparatively little about the character of some of the other brewers of Toronto's nineteenth century, I can suggest to you that if brewing in Toronto can be said to have such a thing as a patron saint, it may as well be William Helliwell. He was intelligent and inquisitive. He was focused and observant. He was scholarly and cultured. He was brave and loyal. One could not hope for a better role model.

Chapter 5

JOSEPH BLOORE'S BREWERY, 1830–1864

Joseph Bloore was born in 1789 in Staffordshire, England, and while it's difficult to say which of the Potteries he hailed from, we know that it was one of those towns that now make up Stoke-on-Trent. His wife, Sarah Lees, was from Burslem and was born the following year. What industry there was in Stoke-on-Trent had to do with potting. The likelihood of being able to rise through the ranks of the industry was slim due to the amount of capital required. In 1818, at the age of twenty-nine, Joseph Bloore and his wife came to Upper Canada.

At that time, the population of the city was still very low, and Joseph Bloore had the opportunity to open a tavern called the Farmer's Arms. It would have been just off the northwest corner of the market square on Stuart's Lane. The area at the time was known as the Devil's Half Acre, presumably because it served as a centre of vice for those farmers who did not frequently make it to town. The Farmer's Arms likely served beer from the Helliwell Brewery at Todmorden Mills up the Don River. For one thing, the Helliwell's off-site shop was also located on Market Square, making it the most convenient product. For another thing, the families appear to have enjoyed a special relationship.

William Helliwell, writing at the end of his life, thought back fondly on picking strawberries with Bloore's daughter, Sarah, when they were mere children in 1825. It appears as though the families acted as godparents for each other. One of Joseph Bloore's sons was named John Helliwell Bloore, and one of Thomas Helliwell's sons was named John Bloore Helliwell. It

Lost Breweries of Toronto

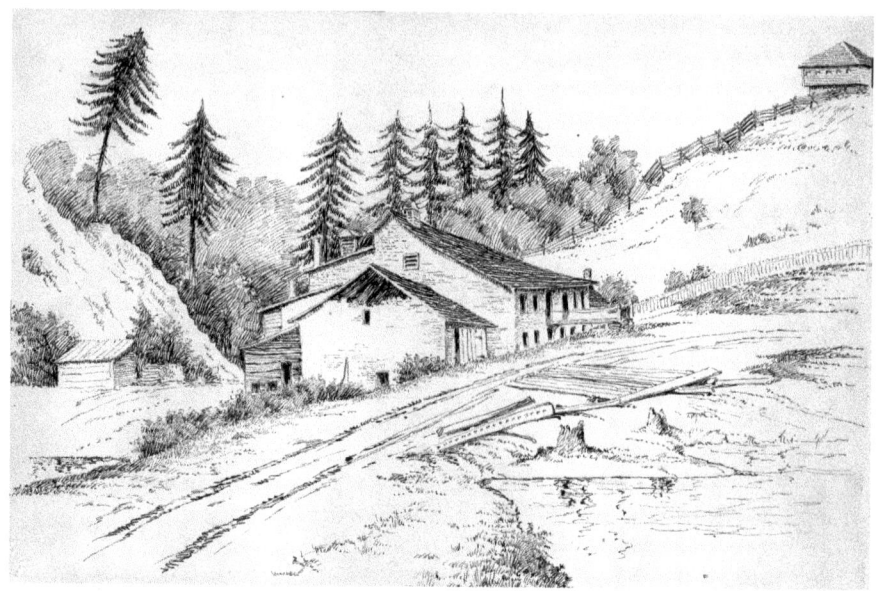

The Bloor Brewery sat at the bottom of the ravine that now houses the Rosedale Valley Road. In the foreground, you can see Bloor's Pond, which powered the mill. In the background, you can see the Sherbourne Street Blockhouse. Bloor's brewery was of low-slung red brick construction, as you can see here. *Toronto Public Library.*

seems likely that Joseph Bloore learned the brewing trade from the Helliwells, although the land his brewery occupied was in his possession before the decision to take up the trade.

Bloore's brewery was located in the Rosedale Valley. The waterway that ran through the ravine at that time was called Castle Frank Brook. The valley was the perfect spot for a brewery, being unoccupied by homes or other businesses, and the creek could be manipulated for more efficient use. Joseph Bloore built a dam of fairly significant size, creating a pond several acres in size that would back up all the way from the location of the brewery near Sherbourne to Yonge Street during the spring rains. The water for grinding grain and malting barley came from this pond to the brewery through a two-hundred-foot sluice. The pond was a favourite of local boys for bathing in the summer and ice skating in the winter.

The brewery itself was of wood and red brick construction, approximately one hundred by sixty, sitting on the south bank of the creek just below the pond. The access point by road was from Huntley Street and was one of the only significant drawbacks to the property. The creek was not wide enough

LOST BREWERIES OF TORONTO

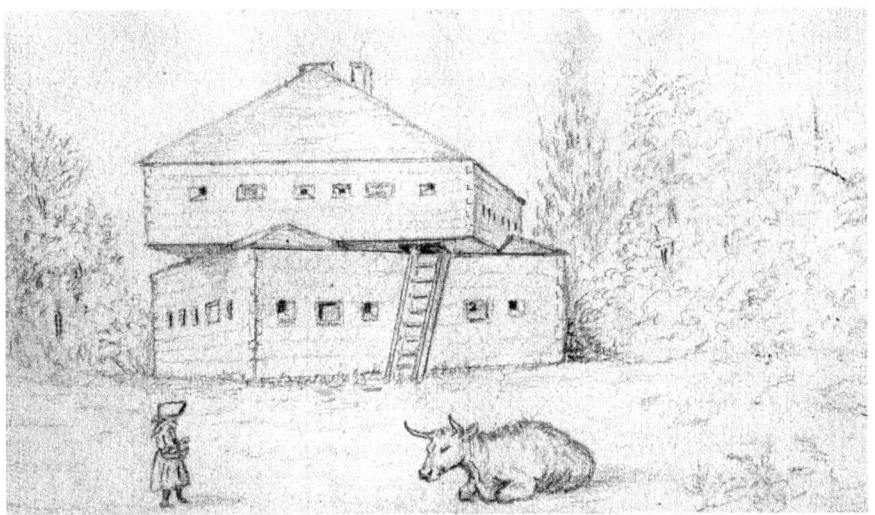

The blockhouses erected at the intersection of main thoroughfares like Sherbourne, Jarvis and Parliament were designed to provide warning of insurrection in the wake of the rebellion in Toronto in December 1837. *Toronto Public Library.*

to support shipment downstream, so full kegs would have to be loaded up the treacherous slope of the ravine on the back of a wagon. It was erected in the fall of 1830, and the malt mill and water wheel were completed in December of that year, just in time for the brewing season.

By 1834, the combined proceeds from the Farmer's Arms and the brewery were great enough that Bloore could enter into land speculation, which he did in partnership with William Botsford Jarvis. Jarvis was the sheriff of the Home District, which at the time ran all the way up Yonge Street to Georgian Bay. He is most famous for having given the order to fire at the rebels during the Battle of Montgomery's Tavern.

The neighbourhood was named after Jarvis's estate, Rosedale, which was considered one of the finest homes in Upper Canada for its chestnut panelled walls and impressive double staircase. The name came from the wild roses that grew on the north side of the ravine above Bloore's brewery. Bloore and Jarvis came close to naming the new village Blooreville but eventually settled on Yorkville in tribute to York, which had been renamed Toronto that year. Bloore would instead have the first concession road named after him.

Bloore retired from the brewing trade in 1843 and spent the latter part of his life developing the real estate around Yorkville, laying out streets and lots for housing and business. He was also a philanthropist, and like the other

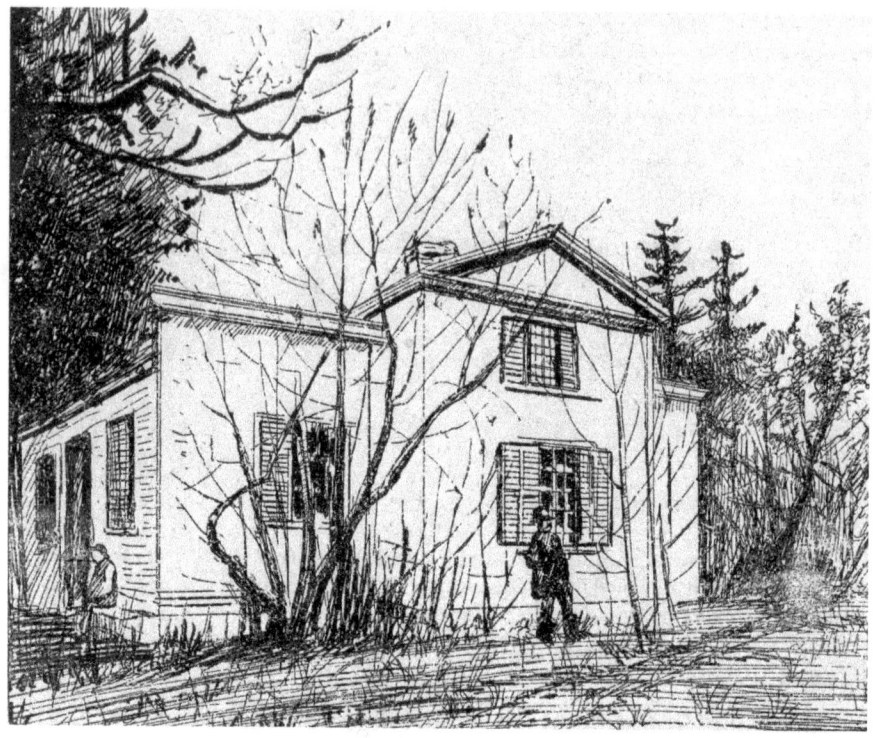

Joseph Bloore's house was located on the south side of Bloor Street, approximately two blocks east of Yonge Street. It was more modest than one might assume, given the wealth Bloore's land speculation generated in the 1830s and '40s. *From John Ross Robertson's Landmarks of Toronto.*

Methodist brewers of early Toronto, he used his wealth to promote social change. The Yorkville Wesleyan Methodist Church, which has since been demolished, was built on land that he donated in 1850. Maps of Yorkville detail temperance halls, which suggests that the philanthropic model of community development amongst Methodists had carried north.

The Bloore Brewery was taken over by John Rose on Halloween in 1843, just in time for that year's brewing season. It was renamed the Castle Frank Brewery, and an advertisement in the *British Colonist* read, "The subscriber begs respectfully to acquaint the inhabitants of Toronto, and this vicinity, that he purchased the above brewery from the original proprietor, Joseph Bloore, esquire, and from his competent knowledge of the business, and a determination to make a first rate article, he hopes to merit a share of public patronage." Rose must have succeeded in his ambition, as the brewery operated until 1864.

LOST BREWERIES OF TORONTO

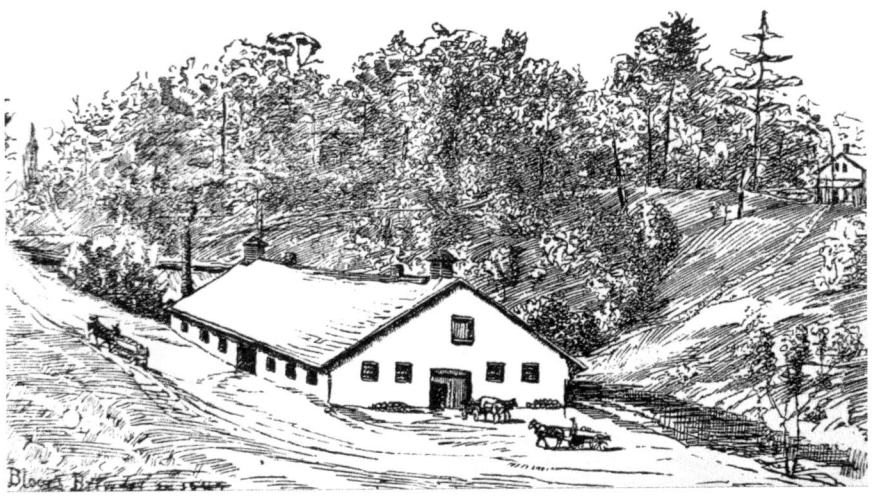

A second view of Joseph Bloore's brewery at the foot of the Rosedale Valley. While creating a pond to turn your mill was a benefit of the location, the steep track up which the wagons had to make their way would have been a perennial difficulty. *From John Ross Robertson's Landmarks of Toronto.*

John Helliwell Bloore, Joseph's son, would continue the family interest in the brewing trade, albeit in the form of cartage and freight for grain. The firm of Clemow and Bloore would ship barley, wheat and corn for the port of Oswego on the south side of Lake Ontario. This allowed them to take early advantage of the agricultural boom in Upper Canada, expanding their trade in the late 1850s all the way to Chicago. The Bloore family had, in the space of forty years from Joseph Bloore's arrival in York, managed to accrue spectacular wealth. All of the business had surrounded beer, graduating from tavern keeper to brewer to handling ingredients.

The brewery is long gone, but if you stand in the middle of the Sherbourne Street bridge and look to your west, you can still make out the outline of Bloore's pond on the north side of the ravine.

Chapter 6
ENOCH TURNER BREWING AND DISTILLING, 1831–1855

Like Joseph Bloore, Enoch Turner came to Canada from Staffordshire. Turner was born in 1792 and was a later arrival in Upper Canada than his contemporary. Their careers followed essentially the same path, although they were an ocean apart. Enoch Turner had been a victualler, or pub landlord, in Lane Delph, Fenton, at the Duke of Wellington in 1818 at about the time that Bloore was founding the Farmer's Arms in York.

Turner was a much later arrival to York, immigrating at the end of the 1820s. His brewery was erected at the southeast corner of Front and Parliament in 1831. At the time, he would have been one of about seven brewers in York. Unfortunately, the majority of his brewery was destroyed by fire in early February 1832. Uninsured, Turner was reduced to poverty by the loss, although contemporary records suggest that he was undaunted by the tragedy. Later that month, he was touring other breweries in York to look at techniques and equipment that would improve his operation.

Funding for the replacement building came from the local community, and it may have been this compassionate act that influenced Turner's attitude for the remainder of his life. While many of the other brewers in Toronto were interested in using the proceeds of their business to create wealth for future generations of their family, Enoch Turner was childless. His legacy in Toronto would be his philanthropic endeavour, his reputation for fair dealing and his tendency to mild eccentricity. This was a man who fed his horses on beer.

In 1848, Turner was responsible for leading the community in the construction of a schoolhouse, which still stands on Trinity Street just south of King. While he donated the funds, the land for the building was donated by Little Trinity Church, of which he was a trustee. The need was created by a series of Common School acts that suggested that local municipalities become responsible for funding public schools. With the City of Toronto slow to raise taxes, available options were restricted to expensive private schools like Upper Canada College and minimal Sunday schooling. Turner would provide education for 240 students. He would also donate heavily in 1849 to an organization that would found the University of Toronto.

The brewery itself was built in stages on the banks of Taddle Creek. It is suggested that some of his employees may have been refugees from the Underground Railroad, in which he was a participant. In 1837, Turner hired a local wood chopper, Samuel Platt, as a clerk. Platt was from Armagh in Northern Ireland and had been providing for himself in York since the age of seventeen. Platt was a man of some substance, having led two companies of militia against the rebels. By 1841, he had developed a distillery in partnership with Turner on the same property.

The main L-shaped building of the brewery was standing by the mid-1840s, but significant expansions were made and can be seen on a plan of the property sketched by John George Howard. Some of the grounds owned by Turner had been used to construct housing, as was typical. By 1854, when Platt and Turner decided to retire, the *Globe* advertised the brewery thusly: "Brick Brewery and Distillery, 116 feet by 42 feet, two storeys high, independent of three capital stone cellars, paved with flags, also a spacious cellar 43 feet by 21 feet, with malt house and granary above, two Malt Kilns with about 3000 feet superficial of malt floors of the best kind, steeps, mash tubs, coolers, malt mill and every convenience for brewing and distilling on a very extensive scale, large granaries, engine house, steam engine and boilers, ice house, stables, sheds."

It is made clear that Platt and Turner were attempting to sell the brewery as a going concern, with improvements being made to allow for brewing to be carried on in the summer. This would have been one of the first such improvements to be made in Toronto. The brewery did not sell as a package, but the equipment was auctioned off separately.

From the auction's contents list, we know that Turner's brewing copper comfortably held 650 gallons. A reasonable estimate for production would have been two thousand barrels of beer annually. It is more difficult to say how much whiskey they would have produced. The difficulty in selling the

property would have been that the competition for the brewery, less than a block away, would have been Copland's East Toronto brewery. The competition for the distillery would have been Gooderham and Worts, which was in process of becoming the largest distillery in North America. Even had Turner and Platt specialized in a single beverage, the premises were not really large enough to compete.

Platt was retiring from brewing and distilling in order to go into politics and to diversify his business concerns. By 1855, Platt was only forty-three years old and had any number of options available to him. Enoch Turner would have been sixty-three and, while well regarded, would not necessarily have been suited to political life, being something of a genteel eccentric. He decided simply to retire to his new home, Allandale, on Sherbourne Street and pursue his main hobby: gardening. The brewery property had had a number of fruit trees and a vineyard in which Turner grew Black Muscat grapes. He would continue to win awards from the Toronto Horticultural Society for years to come. He was recognized especially for his plums and filbert nuts.

The brewery was replaced in the 1850s by the Consumers Gas Works, of which Platt was a board member. The land is now occupied by the administrative center of the Toronto Public Library, which would surely have met with Enoch Turner's approval.

Chapter 7

CAYLEY AND NASH'S ONTARIO BREWERY, 1848–1857

It is not as though all of the breweries that were founded in Toronto in the first half of the nineteenth century were the product of middle-class Englishmen who had come to the New World to improve their fortunes. In at least one case, a brewery founded in Toronto was very much the plaything of an upper-class family. The Ontario Brewery was actually the second brewery of that name in the city. The first brewery briefly occupied a spot near the bottom of Parliament Street. Repetition of brewery names was comparatively normal. There was also an Ontario Brewery in Hamilton, just down the lake.

The Cayley family were well-to-do even before having entered into international mercantile concerns in the eighteenth century. They held a baronetcy in Brompton, Yorkshire. John Cayley had been a member of the Russia Company until going into an independent partnership in trade in 1754. English society at St. Petersburg was a tightknit group. Cayley married the daughter of one of Peter the Great's English shipbuilders and became Consul General of Russia during the reign of Catherine the Great. His son, also named John, took over the business, as trading directly was frowned on in diplomatic circles.

The generation of Cayleys that would end up coming to Canada included the grandsons of the Consul General and were extremely well off. William Cayley, the eldest boy, was educated at Charterhouse and Christ Church, Oxford. His younger brothers, Francis Melville Cayley and John Cayley, were similarly educated, even if they had not the scholarly ability of William.

William would become a lawyer in London in 1835, prior to moving to Upper Canada at some point before 1838.

The main difference between the early days of York and the rapidly expanding Toronto of the late 1830s was that there was a society to buy into. Early settlers were busy with the establishment of a society, however small. The Cayleys were able to purchase some status. Francis Cayley bought 188 acres and renamed the farmhouse on the property Drumsnab. It is the oldest home in Toronto still used as a residence and occupies very nearly the site of the legendary Castle Frank.

Francis had a significant acreage to manage. William had married the daughter of D'Arcy Boulton, ensuring himself a place in the power structure of Upper Canada. John, although he also eventually married into the Boulton family, was not immediately suited to the law or governance. Having comparatively little to do, he decided to become a brewer. His partner, John R. Nash, hailed from Port Credit in Mississauga and may have had some experience brewing with a relative in nearby Whitby.

Cayley and Nash's brewery was not completed until 1848 and is largely forgotten to history due to the short span of its existence. Sitting at the bottom of York Street at the intersection of Front, it was located out over the water on six caissons adjacent to Tinning's Wharf and the Jacques and Hay Furniture Factory. The design was comparatively involved and was one of the lesser works of early Toronto architect John George Howard. At the time, it certainly would have been one of the largest breweries in the province, having been purpose built at a stroke. In many ways, the location was ideal, providing easy access to shipping routes to other parts of Ontario.

The brewery burnt in July 1856 and, with it, any hope of legacy for the future. The year 1856 had a particularly hot summer, with more than the regular number of breweries burning down across the city of Toronto. In about half of the cases, the example we see in Ontario is of brewers rebuilding when faced with calamity. By 1856, Toronto had become very different. The *Globe* records the reactions of the owners: "Messrs. Cayley and Nash were insured in the brewery, which was their own property, between two and three thousand pounds. The vaults, containing the stock of beer and some grain were left uninjured, and a couple of tons of hops were saved by removal. We are told that the charge of breaking open beer barrels brought against the firemen might more properly have been laid against volunteers."

The incident is illustrative of a number of details about Toronto in the mid-1850s, not the least of which is that there have always been citizens who would rather steal your beer than save your brewery.

More importantly, Toronto was at great risk of fire. The coroner's inquest into the fire, which killed five and injured many more, notes that it was the result of poor planning on the part of the city. The water infrastructure was insufficient, and the growth of the city vastly outpaced it. John Nash testified, "I obtained the water for the brewery from the waterworks. It is cut off two days in the week. I firmly believe that if there had been a supply of water from the waterworks, the factory would have been saved. My brewery was destroyed." The inquest found that the fault was indeed with the water company and decided on a verdict of criminal negligence. John Cayley was far more concerned with bringing suit against those found responsible than with the loss of his livelihood.

In terms of the Ontario Brewery, the fire made very little difference. In point of fact, it may have been the best possible outcome. John Cayley's brother William would have told him that change was coming and that the land where the brewery was located would be purchased by the city in order to construct the Esplanade the next year. William Cayley was at that time not only inspector general of Ontario but also a member of the board of railway commissioners and government director on the Grand Trunk Railway's board.

William Cayley was accused by his contemporaries of being unable to rein in government spending in the terms of these large projects. It is not, I think, unreasonable to assume that the money paid by the railways for the Ontario Brewery land was above the market rate. The insurance money paid out for the fire may well have been a small bonus to a business that was destined to close within the next year in any event. The land would become the Grand Trunk Railway's depot in Toronto and, eventually, Union Station. John R. Nash would go on to work in the Ministry of Finance. By the next year, John Cayley would find employment on the boards of railways in Ontario, positions almost certainly ascertained through nepotism.

With the vast majority of Toronto's early brewers, there is the sense conveyed that they enjoyed the work of brewing. For Cayley and Nash, every indication is that they viewed it simply as a manufactured product—as a means to an end for wealth generation. It's little wonder that no information about the quality of the product seems to have survived.

Chapter 8
JOHN SEVERN BREWERIES, 1832–1886

John Severn was born in Wessington, Derbyshire, in 1807 and was a later arrival to York. He would immigrate to Upper Canada from England in 1830 at the age of twenty-three. At the time of his arrival, he was not a brewer by trade but rather set himself up as a blacksmith at Richmond Street. The brewery property that he would occupy was owned by a man named John Baxter, and it was a fairly bare-bones red brick structure when Severn took it over in 1832.

By that time, a great deal of the property around Yorkville was already owned by Joseph Bloore and William Botsford Jarvis. As such, John Severn would have to content himself with a nine-acre parcel of land just northeast of the tollgate at the foot of Davenport road, just up Castle Frank Brook from Joseph Bloore's brewery. Severn's brewery would become his livelihood, and he'd spend much of the next twenty years expanding it into a going concern.

By the 1850s, taking into account the destruction of several of the local breweries by fire, it would have been the largest in the environs of Toronto. It specialized in ale, Porter and Half and Half as a mixture. Charles Pelham Mulvany wrote in 1885 of the height of the brewery's production that "[t]he buildings occupy, brewery 80x225, five storeys; malt house 35x115, containing three storeys. Cellar room the whole extent of the brewery. Employ five hands in the bottling department, five in brewery, three in malt department, two travelling salesmen and one clerk."

Severn's brewery was capable of producing six to seven thousand gallons of beer per week in 1867 with the help of a fifteen-horsepower

LOST BREWERIES OF TORONTO

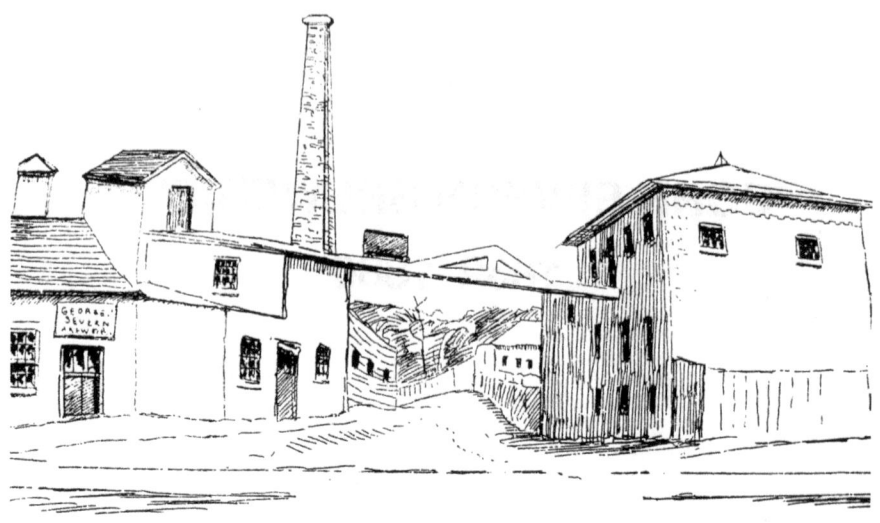

Severn's Brewery Yonge St. Yorkville.

Severn's Brewery as portrayed in John Ross Robertson's *Landmarks of Toronto*. This view would have been from just across Yonge Street, north of where the Masonic Temple stands. From John Ross Robertson's Landmarks of Toronto.

steam engine driving the mill. Assuming a thirsty public and year-round production aided by the icehouses built nearby on Castle Frank Brook, that would have translated to nearly 10,000 barrels of beer per year. While it's very difficult to say when production would have peaked, we do know that by 1885 it had declined to about 6,500 barrels, likely due to the mammoth breweries that had sprung up in downtown Toronto. It would appear that the bottling room was only added in 1882, meaning that the brewery had limited plans for exporting its product to other large markets, where bottling would make sales through licensed establishments possible.

Aside from being a brewer and philanthropist, Severn's other role within the community was as a local politician. Upon the incorporation of Yorkville in 1852, he was one of the first five members of the elected council for Yorkville. The village's crest, which can be seen above the door of the fire hall at 34 Yorkville Avenue, represents his trade with a beer barrel. By that time, Yorkville had become Toronto's first suburb, and an omnibus line, the city's first public transportation, ran from the Red Lion Inn to the St. Lawrence Market.

John Severn was unlucky in marriage. Throughout his lifetime, he had at least three wives: Jane, Aureta and Jane Wilson. His numerous children would require a not insignificant fortune in order to make their way in the world. From the first marriage, he had three sons: George, Henry and John. His second marriage added William to the fold. Severn's brewery was clearly profitable, and with his knowledge of the brewing trade, he set out to provide each of his children with a brewery of his own.

John Severn and his son John left Yorkville in 1850, leaving the brewery on Castle Frank Brook to George and Henry Severn, the two eldest sons. John took his skill as a brewer to where it was in the most demand: the thirsty gold rush town of San Francisco. This was a time

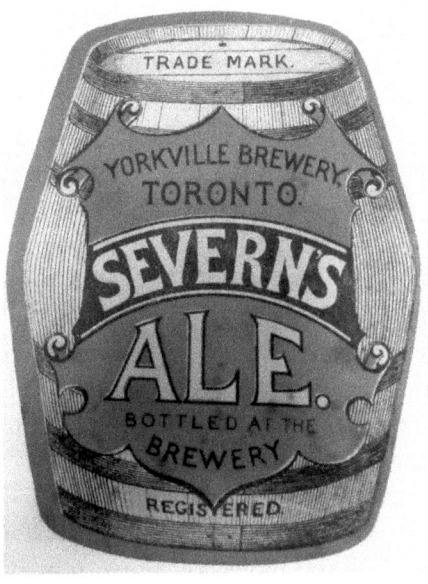

This label for Severn's Ale from the brewery in Yorkville makes a conscious effort to replicate the crest of the town of Yorkville. The scrolling at the edges of the crest on the barrel match up perfectly. The barrel is actually Severn's symbol on the town's crest. *Molson Archive.*

prior to the culmination of the transcontinental railroad, and the voyage would have been made by sea. John and his son entered into a partnership with Jonathan Peel, a recent transplant from England and nephew of the late Prime Minister Sir Robert Peel. The name of the brewery in which they invested is lost (it is tempting to think that it may have been the Empire Brewery, given the pedigrees involved), but it is clear that John Severn lost interest upon the death of his son.

After a brief sojourn in England, Severn returned to North America, stopping briefly at his home in Yorkville before making his way to Davenport, Iowa, in 1858. Davenport may seem an odd choice, but it was at the top of the steamboat routes for the Mississippi River, and the trip to Davenport was not particularly arduous due to lake boats and eventual rail connections from Chicago. John Severn purchased an existing brewery that was situated next to the Mississippi and renamed it the Severn Ale Brewery. Throughout these expansions to the family business, there was not much change in the product that the breweries churned out. These

would play to the strength of the family's experience with ale and Porter. The Davenport brewery would go through the hands of all of Severn's remaining sons, and it was where George and Henry found themselves when John returned to Yorkville in 1864 to reclaim from them the brewery that he built.

John's youngest son, William, would find himself with a brewery of his own after a brief period as an apprentice in Davenport. It was opened in Belleville, Ontario, in 1874 and would last until 1888—two years longer than the original brewery in Yorkville. For a brief period in the 1870s, John Severn actually managed to fulfill his dream of seeing all of his sons operating breweries of their own. Perhaps as a result of the expertise that he displayed, he was made the first president of the Canada Brewers and Maltsters Association in 1878.

For all of the effort that went into creating regionalized breweries for his family, including brief periods as a hop factor in the early 1850s and tavern owner in the 1860s, John Severn managed one achievement that influences the lives of Torontonians to this day. In 1875, acting as reeve of Yorkville, Severn was the guiding hand in obtaining drinking water for the town.

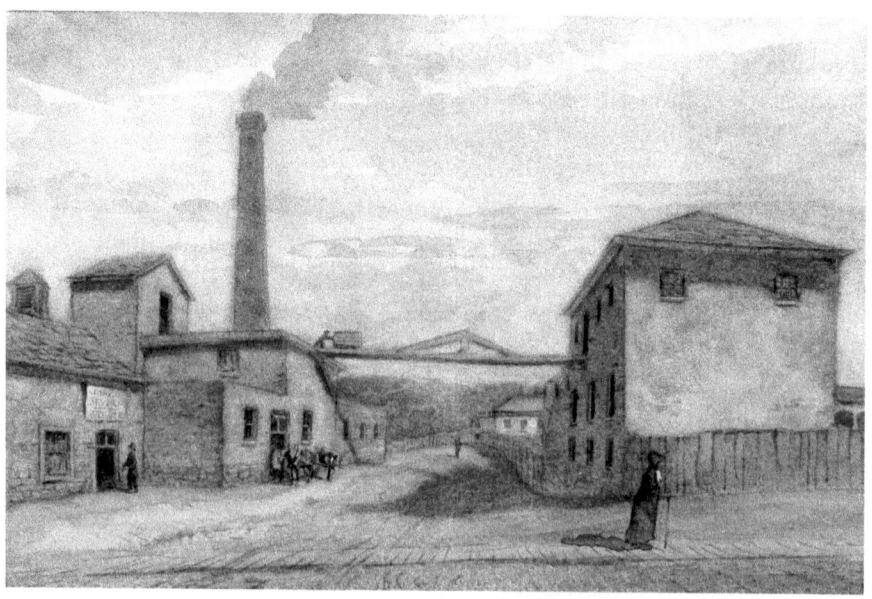

This view of the Severn Brewery is from Yonge Street. The inclusion of a third-storey platform, complete with railcar to transport goods between the malt house and brewery, would have meant a real savings on time, although quite slippery in winter. *Toronto Public Library.*

LOST BREWERIES OF TORONTO

Although many options were considered, the creation of the Yorkville Waterworks was so clearly his responsibility that a banquet was thrown in his honour. It cannot be said to have been a purely selfless act of public service, as it allowed the creation of a fire brigade and made it possible for the brewery to stop using spring water piped in from Summerhill. However, the infrastructure that Severn created to service Yorkville still makes up the bones of today's system thanks to improvements carried out in 1910.

In Severn's final years, there is an episode that highlights a reason that the brewery may have ceased to operate. Yorkville, having had significant Methodist influence in its foundation and growth, was faced with a decision on the Dunkin Act in 1876. A petition of local ratepayers was deemed insufficiently signed to effect the restriction of liquor to four locations within the town. Local option temperance failed, and it is difficult to see how there could have been any other result with one of Toronto's most prominent brewers chairing the committee.

George Severn would inherit the brewery in a rapidly changing Yorkville that could no longer tolerate breweries, slaughterhouses or brickworks amongst its residences. It was this mood in a growing population (five

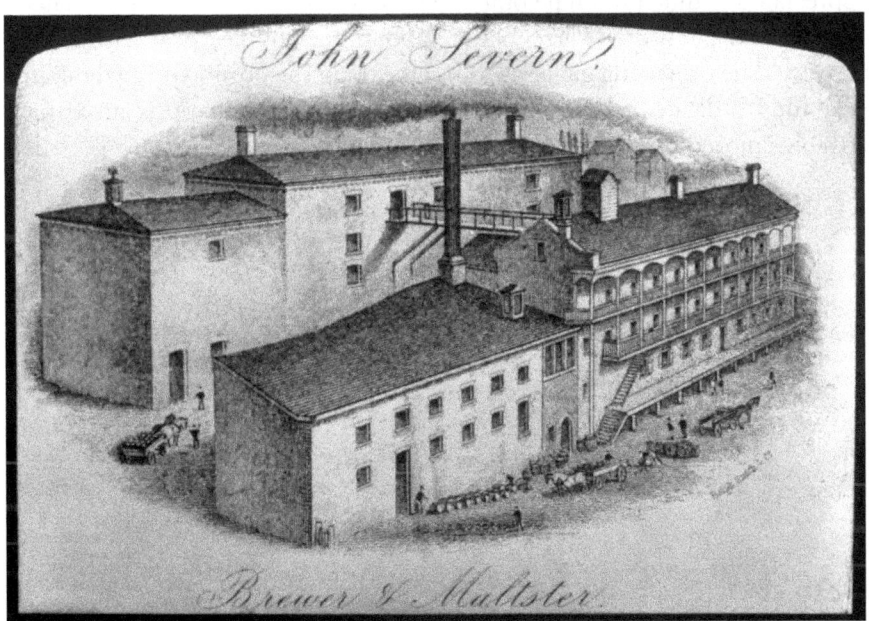

This lithograph of Severn's Brewery seems to be a view from the northeast of the facility. Note the residential portion of the building in the right foreground with its gallery-style balconies, almost reminiscent of an English coaching inn. *Toronto Public Library.*

thousand in 1881) that viewed the neighbourhood as a residential suburb rather than an independent village that led to drawn-out legal battles over the sewage the brewery created in the 1880s. Its eventual closure happened within three years of the annexation of Yorkville. The *Globe* had forecast this eventuality in 1852 at the incorporation of the village: "It will soon come to be a subject of discussion whether Yorkville ought not to be annexed to Toronto. It is not to be expected that the city will remain 'cabin'd, cribb'd, confined' within its present narrow limits for any great length of time; it will soon grow too large for its garments and a good slice of the township of York will be necessary that it may have ample room and verge enough for its gambols."

The brewery property on Severn Street is occupied now by the Studio Building, which housed many of the Group of Seven painters during the early portions of their careers. Tom Thomson painted in a shack on the property, and it was in that shack that his masterpiece *The West Wind* was found upon his death in 1917. The building was favoured by artists for its north-facing windows and for its view of the valley receding north across Yonge Street and the foliage on the opposite slope of the ravine. Severn appreciated as much when he built the brewery. As Henry Scadding related, "There is a picturesque irregularity about the outlines of Mr. Severn's brewery. The projecting galleries round the domestic portion of the building pleasantly indicate that the adjacent scenery is not unappreciated: nay, possibly enjoyed on many a tranquil autumn evening."

Chapter 9

SPADINA BREWERY, 1837–1894

It may seem by now that owning a brewery in the early days of Toronto was a license to print money—that everyone who attempted it succeeded in creating some wealth out of an industry that was much in demand. There is at least one exception to the rule. The Spadina Brewery failed spectacularly throughout much of the nineteenth century to create fame or fortune for its owners.

In choosing a site for your brewery, there are criteria that must be met. First of all, a brewery requires a ready source of water. The Spadina Brewery had that, but the waterway's namesake should perhaps have been a warning sign of the likely fate of the business. It was situated on Russell Creek, a small waterway named for an early government official, Peter Russell. Russell was an inveterate gambler who was forced to leave Cambridge, and subsequently the army, due to his debts. At the end of his life, Russell found himself with six thousand acres of land surrounding York that he could not move, despite it being one of the busiest periods of land speculation in Upper Canada's history.

In order for your brewery to succeed, you need customers. When the Spadina Brewery was first operating in the late 1830s and early 1840s, it must have seemed like this would not be a problem. It must have seemed that if the brewer could simply hold on long enough and produce a good product, the expansion of York would bring the customer to him. College Street was being laid out by Robert Baldwin to the north in 1842, and there was every indication that the estates of the great and good would be subdivided into

tracts of housing in short order. In the meantime, George Taylor Denison's troop of cavalry, mustered nearby at Bellevue, and the custom of spectators at the nearby St. Leger Race Course and Cricket Grounds would almost certainly prove enough business to weather the period of development.

The Farr Brewery had been more remote from York, but it had the significant advantage of catering directly to the soldiers at Fort York. The Helliwell Brewery had been in an obscure location, but that hadn't mattered because of its dedicated bottle shop and cellar at the market square. When the Spadina Brewery was founded, it made up a large portion of a subdivision called the Meadows, which was surrounded by practically nothing. The northern boundary of the city in 1837 was just north of Queen Street. Rather than spreading north, York had stretched along the lake, and the majority of the population and industry was concentrated in the east end of the city towards the Don River.

The problem with the Spadina Brewery was how good an idea it seemed. Every owner who came along for sixty years must have believed that he could make it work—that this time it would be fine. This time, the owners must have thought, the population boom will come in this direction. Many of the original buildings in Kensington Market stand to this day, but they were not erected until the 1870s.

When the property was subdivided from the Meadows, it was owned by Henry Sproatt. Sproatt was from Cumberland, England, and had come to Canada in 1821. There's some question about when the brewery would first have been erected. Some sources have it founded in 1837 by John Walker. What is known for certain is that it left Henry Sproatt's ownership about the time that the second brewer, George Craig, left the business.

Adam McKay was the owner from about 1844 to 1857. McKay ran into any number of problems in the running of the brewery on a year-to-year basis. The first record in the *Globe* is from the brewing season of 1849, and the situation had already begun to deteriorate. "Hard Times!" it begins. "Little Money and No Credit!" it continues. McKay's advertisement goes on to explain that due to the lack of currency in circulation and due to the problems he has experienced in the past with creditors, beer is available on a cash-only basis for the season of 1849–50. He seems to be brewing on a system of first and second runnings, but the commonality between the products is that they are all reduced to sell. As a final indication of the state of things, he makes it clear that there are 1,500 bushels of malt for sale.

McKay must have assumed that development was coming and that his persistence would be rewarded. He struggled with the Spadina Brewery for

the next four years. The problem was mostly one of access to the market. He was far enough away from downtown Toronto that he required agents to bottle his beer for him. The first of these, John Alanson, quit in 1851 to go into business for himself. By March 1853, McKay's beer was available through two locations in Toronto: a proprietary Ale Depot across from the newly erected courthouse on Adelaide Street and the Beaver Inn on Queen Street West, which acted as a bottling establishment. By October of that year, the brewery was listed for sale or rent, with a malting capacity of seven thousand bushels and a production capacity of 1,500 gallons per week (barely 1,500 barrels per year).

In 1854, McKay listed the brewery in the *Globe* as inoperable for the season and sold all of the casks that he had in his possession, along with many of the tools for malting and the tack and harness for the stables. By 1857, he had ceased trying to sell it as a brewery at all and was merely listing the dimensions of the property: 200 feet on St. Andrew and 250 feet on Eliza Street—eight to ten first-rate building lots. The final mention of McKay's association comes from August of that year, when the contents sale of the property included his furniture, clothes and other possessions.

Samuel Greey was listed as the owner two months later. He advertised a selection of "Fine Bitter Ales, Pale Ales and London Porters." By 1864, the business was going so badly for Greey that he was attempting to sell it. In the same newspaper column was advertised his new venture: flour milling and animal feed. In an era when barley was so plentiful as to be practically free, the Spadina Brewery performed so badly that it could not add value to barley. Greey had made the conscious choice to attempt to mill it for fodder rather than make beer with it. By 1866, the Spadina Brewery was in the hands of an insurance company.

A second generation of the Sproatt family must have purchased the brewery from it. By 1868, Charles Sproatt, himself an engineer who had worked surveying the Toronto and Guelph Railway, was the brewer and was backed by George Brown as a silent partner. By nature, Sproatt was industrious. He enlarged the brewery with additional buildings and a steam engine to aid with the milling. At that time, the brewery could produce two thousand gallons per week with a full complement of four employees. They produced ales and Porters of varying strengths and had the capacity to age the beers in the stock cellar and vaults beneath the brewery.

It's worth pointing out that the Sproatt family were the only owners of the Spadina Brewery who were able to make it a saleable property. In fact, they sold the brewery twice. Charles Sproatt left to become one of the engineers

for the City of Toronto and was responsible for the creation of the Garrison Creek sewer. The sale of the property probably funded the education of Charles Sproatt's son, Henry, whose architecture helped define Toronto's visual style.

John Ball owned the brewery from 1870 until 1887, and while he was preoccupied with his role as an alderman for the city, he did manage to make some improvements to the brewery and operate it for a time as a profitable business. Under Ball, the buildings of the brewery would take up the entire length of the property on St. Andrew Street, with the main brewery occupying an eighty- by two-hundred-foot floor plan. The stables provided plenty of space for horses and wagons.

By the time Ball had taken over the property, there was finally a market for the product. The difficulty was that the neighbourhood was changing and partially under Ball's direction. He was chairman of the board of works for the city, after all. Russell Creek was buried in 1876, and the Denison and Crookshank estates, which had previously been largely empty space, were subdivided to create the Victorian row housing that gives Kensington Market its character. The population boom that the brewery had been waiting for had finally come, but the downside was that the area had become too residential to support the brewery. Additionally, the brewery was now too small to compete with the newly constructed ones nearer the Don River.

The final owners may have been the ones with the worst luck. John S.G. Cornnell and Arbuckle Jardine took over the Spadina Brewery in 1888. It was their second kick at the can. The Farr Brewery, which they operated until the time of its demolition, was their first attempt. Cornnell had been the son of the brewer, and Jardine was comparatively wealthy, owning significant land near Wychwood Park. Under their direction, the brewery finally ceased to operate in 1894.

It may look in retrospect as though the brewery was cursed, but that is not really the case. The Spadina Brewery is a cautionary tale that we can learn from in the modern era. Real estate speculation has always been an active field in Toronto, but it is foolish to believe that the future can be predicted with total certainty. Even in a system where a population boom is coming, the timeline may not work out in your favour.

Chapter 10
JOHN WALZ/IGNATIUS KORMANN BREWERY, 1857–1944

Toronto's first brewery was located at the northeast corner of Richmond and Sherbourne and eventually migrated across the street. By 1858, all that remained of the brewery was a large shed suitable for use by a blacksmith or other small concern. Even had the majority of the business escaped its fate in a fire, there were significant problems it would have had to overcome. For one thing, it was small and ill-equipped to compete in a city with breweries the size of Aldwell's William Street Brewery or Copland's East Toronto Brewery. Either would have produced ten times as much beer. For another, the constant shift in ownership meant that there was no durable trademark, brand name or reputation associated with the location.

Toronto was changing rapidly. You may have noticed by now the common thread shared by the majority of the earliest brewers in the city: they were typically English. They were, more often than not, from the Midlands or Yorkshire. They were middle class, literate and usually practiced in some manner of trade. By the middle of the nineteenth century, the average immigrant was Irish. In 1847, during the Great Famine, the number of Irish immigrants who passed through Toronto doubled the actual population of the city. In reality, they were not immigrants so much as refugees from a situation of terrible hardship.

That is not to say that they were the only immigrants. Europe in the 1850s was a dangerous place due to revolts that had taken place at the end of the previous decade. Some fifty thousand Germans, a majority of whom were from Baden-Württemberg, immigrated to Berlin, Ontario,

between 1830 and 1850. That figure does not include those who settled elsewhere in the province.

Yohann Gotthilf Walz was a latecomer, arriving in Canada from Weilersteussling in 1857. Rather than moving directly to Toronto, he gravitated in the direction of Berlin and settled in Preston near Galt. By 1857, the Waterloo region was awash in breweries. Like the English settlers, the Germans were producing the beer that they had enjoyed in their homeland. It was lager and probably of the kind that they had in Baden-Württemberg and Alsace: zwickelbier or kellerbier. They had started early, and brewers were now moving into the countryside to towns like Neustadt and Carlsruhe. In some cases, they would even go as far as Owen Sound.

John Walz decided against moving in that direction. Instead, he purchased a large block of land in Toronto on the southeast corner of Richmond and Sherbourne and began to develop the property. In addition to a series of row houses on Sherbourne Street, Walz operated a lager brewery. It had all the attendant outbuildings, including icehouses and stables. The Walz Brewery actually used the remaining shed from the Shaw Brothers' brewery for storage. Walz did not produce a great quantity of beer: approximately eight hundred gallons per day. His brewery existed in partnership with Frederick Warner's Lager Bier Saloon on Yonge Street near King. Subsequently, Walz would open his own hotel on the property, the Germania, in order to be able to serve his beer closer to the brewery.

That his brewery should have been in the same location as the first in the city illustrates a parallel in the experience of the first settlers and the German immigrants to Toronto. While the earliest settlers had to carve a niche in the wilderness for themselves, establishing their creature comforts and cultural trappings, so, too, did the Germans find themselves struggling to create a community in a city whose entire population had come from the United Kingdom and Ireland. Everyone else shared a language, but the Germans were the butt of jokes about their accents and customs.

John Walz was part of the first wave of German immigrants to settle in Toronto, and his story is extremely similar to some of the earlier brewers. He bought a large block of land and used some of the wealth generated by the improvements to help create institutions that would benefit the community. He was one of the founding members of the Bond Street Lutheran Church, which was widely attended by Toronto's German-speaking population. His daughter, Mary, was even the organist during Christmas celebrations. Walz was also heavily involved in the German Benevolent Society. Rather than creating schools, this was a society that ensured a stipend if you grew infirm

and a decent burial if you passed away. Perhaps most importantly, Walz acted as the unofficial head of the neighbourhood and a significant political influence for St. David's Ward. He held meetings at his brewery and would have been able to deliver the German vote.

Until his death at the age of ninety-two, Walz retained the majority of the property on the block that housed the brewery. He had a calming influence on the neighbourhood. As one memoirist recalled, "The people east of Sherbourne were conservative and quiet and many German families lived there. But west of Sherbourne it was a different place, peopled mostly by immigrants from the Old Sod, full of vim, vigor and vitality, noisy, rowdy and good hearted. Many a brannigan was fought in the middle of the road of an otherwise quiet evening...The trouble with Duchess Street was not its fights but in its love for John Barleycorn, and this brought hardship to many."

Compared to the bustling trade in whiskey that resulted from having Gooderham and Worts (the largest distillery in North America) mere blocks away, beer was positively a temperance beverage. While ales were usually north of 6.5 percent alcohol in Toronto before 1900, lagers were usually between 3.5 and 4.0 percent. Compared to their Irish neighbours in Corktown, the Germans were sober and sensible. You might have been able to get drunk on Toronto's nineteenth-century lager, but you would have had to work at it.

John Walz was for twenty years Toronto's only brewer of lager. He referred to his product as "The Cream of Canada." In 1871, he was charging one dollar per quart with a deposit for the bottles. Within the two and a half decades that Walz brewed, the style of beer that he had pioneered within the city was adopted as a regular product by several of the leading breweries. He exhibited a sense of humour about his competition. In May 1879, Eugene O'Keefe began to produce lager in massive quantities. Walz's advertisement from December of that year reads, "The Cream of Canada—Hurrah for Lager John!—Who says he is dead?"

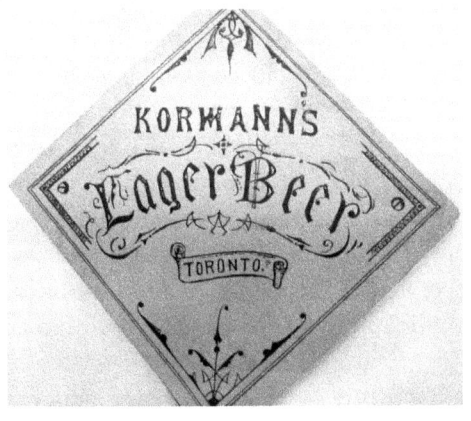

Kormann's lager beer was slightly different than the other products on the market in that the label, while boasting some ornamental flourish around the edges, was pretty basic. There is only so much information you need to convey about beer. *Molson Archive.*

Lost Breweries of Toronto

Walz retired from brewing in 1881, but he maintained ownership of the brewery and the land underneath it until 1889. The new lessee of the brewery would be Ignatius Kormann, who was the silent partner, preferring to allow a young brewer named Lothar Reinhardt be the face of the business.

Ignatius Kormann's story reflects more typically the experience of the German settler in Upper Canada. Born in 1836, Kormann immigrated to Ontario with his parents in the 1840s from Drussenheim near Strasbourg. He became the first merchant and postmaster in Carlsruhe, Ontario, in 1864. He remained in that position for four years, eventually becoming reeve of Carrick between 1869 and 1873. Kormann was a trilingual government functionary in a part of Ontario's Huron Tract that was ripe for settling. He was influential with the settlers in Bruce and Huron Counties for his ability to act as a seamless go-between for communities that spoke different languages.

Someone at the provincial level must have taken note of Kormann's abilities because in 1878 he was sent to the Paris Exhibition as Ontario's representative. With a budget of $800 (a significantly larger figure in those days), Kormann was tasked with persuading people to settle in the Huron Tract but similarly acted as an agent for those businesses that wished to promote themselves. While Kormann never sought formal office within the province of Ontario, his connections to communities across the province made him an important voice on immigration policy. He believed in filling the map with settlers for agricultural purposes. His role in terms of German settlers was practically identical to the roles that Peter Robinson and Thomas Baines played in settling early Irish settlers in Peterborough. Coincidentally, both of those men would become brewers upon their resignation from the position.

Under Kormann and Reinhardt, the Kormann brewery would expand from its initial production of 800 gallons per day to nearly 2,500, increasing the annual capacity to about twenty-five thousand barrels per year. The brewery employed fifteen men and two travelling salesmen who sold the beer across the country. It produced a single style of lager, for the most part, but did produce a bock in imitation of the famous Bavarian Salvator for the Christmas holidays.

By 1901, with the improvements that Ignatius Kormann and his sons had made, the brewery stood four storeys tall, approximately sixty by one hundred feet square. The trappings had all been replaced due to a fire in the engine room in the late 1880s, and the brewery was powered by a thirty-horsepower steam engine. Unlike some of the older ale breweries in Toronto, the Kormann brewery had been forced to modernize. Its beer was available throughout Ontario and Quebec for the first time because it had

recently added a bottling department that would allow it to ship both pints and quarts of its premier brand, a table beer called Perfecto Export. In the face of the increasingly influential temperance movement, a table beer was a strong selling point.

When Kormann passed away in 1891, he left behind a successful brewery that would be managed by his youngest son, Joseph Kormann. John S. Kormann acted as president of the company. The Kormann sons were interested in a number of taverns across Toronto. Franz J. Kormann ran the Germania on Duchess Street. Harry moved to Chicago to start up his own business concerns. Ignatius Kormann also owned an interest in a hotel called the Grand on Adelaide Street West in partnership with Daniel Small. In 1891, three years after the passing of his first wife, Small married Kormann's daughter, Josephine. Small's son, Ambrose, would marry Theresa Kormann in 1903, making the father and son brothers-in-law.

The marriage came only a month after the passing of Kormann's wife, Mary, and due to that tragedy was attended only by members of the two families. In point of fact, Mary's will was still in probate at the time of the wedding. Ambrose Small's character has historically been the subject of much discussion, as it's intimated that he devoted a great deal of attention to the showgirls employed in his burgeoning vaudeville and theatre circuit. The wedding allowed him to purchase the Grand, now a theatre, with the money that made up Theresa Kormann's inheritance. While she was travelling in Europe, he had a secret love nest constructed in the building for the purpose of entertaining women.

In 1919, Ambrose Small decided to sell his chain of theatres to a larger company for $1.7 million. He would not end up enjoying the proceeds of the sale. On December 2, 1919, while Theresa was depositing a cheque for $1 million, Ambrose purchased for her some furs, jewelry and a Cadillac. After a brief meeting with his lawyer that afternoon, Ambrose Small disappeared into thin air, never to be seen again.

The newspapers of the day were enthralled, characterizing Theresa as the "buxom heiress" of the Kormann brewing fortune and suggesting that she may have played a role in the disappearance when she failed to report that Ambrose was missing for an entire month. The knowledge of his infidelities might not have been widespread, but those in the know had reason to attribute jealousy as a motive if she were considered a suspect. She is on record as having simply assumed that Small's wandering eye had caused his absence, stating that she believed "my Amby is in the hands of a designing woman, somewhere, and will come back."

Left: City Club Breweries existed for only seven years in total and less than six months as an independent company. The challenge of creating new brands for a brewery without any heritage led to uninspired fare like this Four Star Stout. *Molson Archive.*

Right: It is difficult to know what the City Club Brewery was attempting to emulate in making a Bristol ale. While there were historically breweries in Bristol, my suspicion is that it thought the name sounded good. *Molson Archive.*

Perhaps it was the reputation of the Kormann family that saved Theresa from being taken more seriously as a suspect in the matter. After all, she had grown up as a soloist in the church choir and had stated her intent to donate the entirety of his estate to the Catholic Church. Private detectives would investigate the disappearance for years. Newspapers would report sightings of Ambrose Small in Boston, Minneapolis and even as far away as the morgue in Paris. This was at least in part because Theresa had posted a sizeable reward for information leading to his discovery. In 1923, he was declared dead for the purposes of probate, and Theresa Kormann found herself with a sizeable inheritance for the second time in her life.

No one was ever able to discover what happened to Ambrose Small. The fortunes of the Kormann Brewery, however, are a matter of public record. John S. Kormann, president of the company from 1891, was at the helm when it was shut down during prohibition. While it would experience a brief resurgence independently as the City Club Brewery in 1930, it was eventually bought by a succession of competitors before being shut down

by E.P. Taylor's Canadian Breweries Limited. At the time of John S. Kormann's death in 1926, the fame of the Kormann Brewery had already been surpassed by the scandal surrounding Ambrose Small's disappearance. Despite the sensationalism that eclipsed it, the Walz-Kormann heritage is an important part of the history of German Canadians in Ontario.

Chapter 11
THOMAS ALLEN/LOTHAR REINHARDT EAST END BREWERY, 1862–1957

Although it was a comparative latecomer to the Toronto brewing scene, the Beech Street Brewery proved to be one of the most city's enduring. It was purpose built for Robert W. Defries in 1862 on what is now Mark Street, one block south of the Dundas Street Bridge. Defries represented the first generation of his family to be born in Canada. His father, also a Robert Defries, had come to Canada in 1829 from his home in Devonport near Plymouth, Devon. The elder Robert Defries had been able to secure a stable position in the legislative assembly as postmaster. While some men had the audacity to branch out into several careers simultaneously in early Upper Canada, there has always been something to say for good steady work.

Defries was equipped to go into the brewing business due mainly to his association with the Davies family. He was the son-in-law of Thomas Davies Sr., having married his daughter, Elizabeth. The brewery that he had erected was modest in size by the standards of the time but contained "all the conveniences which an intimate knowledge of the business prove to be requisite." The brewery was on the banks of the Don for the purposes of easy transport to the harbor. It was made of red brick and had a footprint of fifty-six by thirty-two feet. The basement had three cellars for aging its product. The second floor was used for malting, although the kiln was located in the basement with the stock. The third floor was for brewing, cooling and office space.

While Robert W. Defries would sell the brewery in 1868 and pass away shortly after in 1871 at the age of only thirty-eight, his sons would continue

LOST BREWERIES OF TORONTO

While the Don River would have originally run directly next to the East End Brewery, the straightening of its course meant that breweries could have their own rail sidings, greatly enhancing their ability to export product to other parts of the country. *Thomas Fisher Rare Book Library.*

in the brewing industry. Both would meet with unfortunate accidents. Robert H. Defries went to work for his uncle, Robert T. Davies, at the Dominion Brewery as soon as it opened. In 1881, while working in the malt house, he attempted to grab a ride on the grain hoist from the basement to the first floor. It is thought that he lost his balance while stepping from the hoist to the ledge of the first floor and fell backwards, landing awkwardly. Thomas W. Defries also worked for the Dominion Brewery and was crushed to death by a rearing horse while attempting to affix a wagon harness. Thomas's wife decided on the basis of the continuing family tragedy that their son would not be allowed to go into the brewing industry.

When Robert W. Defries sold the brewery in 1868, it was to the partnership of Thomas Allen and Hugh Thompson. Thompson was largely involved in agricultural societies in the city but was, in the context of the brewery, the moneyed interest. Thomas Allen was the one with all of the brewing ability, although it was a trade that he had taken some pains to learn during his sixteen years in Toronto. Allen had served at Ridgeway during the Fenian Raids of 1866 as a sergeant in the Tenth Royal Regiment, which may have made him an attractive prospect for the purchase of the brewery to Defries. Mark Defries, Robert's brother, had been one of the few casualties of the Queen's Own Rifles at the same engagement.

LOST BREWERIES OF TORONTO

Allen was originally from County Armagh in Northern Ireland. He had intended to come to Canada in 1850 at the age of twenty, but the Atlantic crossing was so treacherous that winter that the ship returned to Cork. He attempted the voyage again in 1851 and, finding himself unemployed in Toronto, went to work for his cousin. By this time, Samuel Platt was a partner in Enoch Turner's brewery and distillery. Thomas Allen was likely in the employ of that concern until 1855, when Platt closed it to diversify his business interests. Allen would end up working at the Copland brewery for a period after that, his credentials secured in the brewing world.

Allen purchased Hugh Thompson's interest in the brewery, now styled the East End Brewery, in 1875. His entrance into political life began in 1877, as he became an alderman for St. David's Ward. He was politically a staunch Tory and Ulsterman and was a founder of a lodge of the Orange Order. He would continue to serve in his capacity as alderman throughout the 1880s and ended up bringing his son into the partnership in 1880. Oliver Henry Allen stayed with the business for only five years before joining the army. He was lieutenant in the flying column of militia that was sent to put down the Riel Rebellion in 1885. Oliver would marry and settle in Revelstoke, British Columbia, becoming the first brewer in that location.

Allen would sell the business in 1888 to the man in Toronto who most needed his own brewery. Lothar Reinhardt was not like the other brewery owners of the late Victorian period in Toronto. For one thing, he had a formalized education in brewing. Reinhardt was born in 1842 in Cologne and had been a brewer from early adulthood. He had attended what was, at the time, one of the only brewing academies in the world at Worms in Germany. His apprenticeship following his studies was completed at Paulaner, which had been secular since 1802. He also studied briefly under Johann Hoff at Cologne, whose malt extract was recognized all over the world.

Reinhardt had brewed in both Paris and Milwaukee before settling down in Toronto in 1877. By 1878, he was working for John Walz at his brewery on Duchess Street. In 1881, he leased the brewery from Walz with the backing of Ignatius Kormann, who would continue it after they ceased their partnership in 1888. Unlike Thomas Allen, who had political concerns to draw his attention, Lothar Reinhardt only knew life as a brewer. By the mid-1890s, he had well and truly captured the attention of the citizens of Toronto. In 1897, the *Globe* was reporting on his seasonal bock beer:

Its first appearance in Canada, it is claimed, was when it was introduced by Mr. Lothar Reinhardt in 1878, since which time it has attained the

Left: Lothar Reinhardt temporarily styled the Mark Street brewery the East End Bavarian Brewery. He was eventually content to simply refer to his product as Bavarian lager. *Molson Archive.*

Below: Compared to some of the other trademarks floating around (elks, beavers and maple leaves), Lothar Reinhardt's use of a hand clutching a foaming pint seems to get right to the point. Reinhardt didn't have to buy into a sense of nationalism since he identified as Bavarian. *Molson Archive.*

highest point of perfection and popularity of any beer brewed in Canada. It might be said that the malt used by Reinhardt & Co. in coloring the bock is the same as used in the preparation of Dublin Stout, and is procured form Messrs. Hugh Baird and Son of Glasgow. This popular season beer brewed by Reinhardt & Co. will be ready at the latter end of this week.

One of the greatest secrets to Reinhardt's success was that his formal training had allowed him a depth of knowledge of ingredients and processes that could not be rivaled by the competition in the city. There were other trained brewers, but they were not the owners of the companies that they worked for, and compromises were made after the product development was complete. Reinhardt was actively attempting to emulate separate German styles of beer that were not available from any other source in the province. In addition to the seasonal bock, he was brewing a Bavarian lager at approximately 5 percent alcohol and a very popular malt extract beverage called Hofbrau. The beers that Reinhardt produced would have been recognizable by style to enthusiasts today.

The marquee product was his Salvador lager beer, which, he claimed in the advertising material from the first decade of the twentieth century, was Canada's most famous brew. The advertisement, not content merely to suggest that the beer emulated Paulaner's famous Salvator Dopplebock, outright declared that Reinhardt possessed "the secret formula and process for brewing" the Lenten specialty. While it's tempting to dismiss the claim

Left: If Salvador was brewed to the original Paulaner recipe, as is suggested by Reinhardt's advertisements, then it would have contained significantly more than 9 percent proof spirits. *Molson Archive.*

Below: This letterhead from the early twentieth century displays the Reinhardt Brewery at its full ninety-thousand-barrel operating capacity. It also displays the dual lions, which were Reinhardt's symbol both on his trademark and in front of his home on Jarvis Street. *Thomas Fisher Rare Book Library.*

for the reason that a number of breweries made products called Salvator, Reinhardt claimed to have letters patent for the product and sole right to produce it in Canada. Additionally, the history of the Paulaner Brewery related in the ad is very accurate concerning its timeline.

Whether he had the exact recipe or not, Salvador was certainly a quality product, a fact that probably had more to do with the brewer's acumen than anything as innocuous as a recipe. By 1901, the brewery had expanded considerably from the three-storey brick structure that Robert Defries had started with. The capacity of Reinhardt's brewery was 8,000 gallons per day, or about ninety thousand barrels per year. The cellars of the brewery had a capacity of 750,000 gallons, which is less surprising when you remember that at least two of the beers being made required six months of lagering. The brewery employed sixty hands and needed stabling for twenty-eight horses to keep up with delivery. The *Toronto Daily Star* painted a picture of a state-of-the-art brewery:

> *Passing upstairs we visited the board room, fitted up with all possible conveniences and adjoining it the chemical laboratory, which is provided with the most approved appliances. Descending again to the brewery proper we were delighted with the rich fragrance of the hop-room, where were stored rows on rows of bales of Eastern Townships, British Columbians, Californians, and Oregons with Bavarians from the German Empire…a noticeable feature all over the brewery—and a matter of the utmost importance to the lover of good beer—was the absolute cleanliness maintained everywhere.*

It's easy to see why Lothar Reinhardt's beers enjoyed a reputation even in Europe. In 1905, Salvador beat out 167 other breweries at the Universal Exposition in Liege to win a gold medal.

At a time when other breweries were run by committee and attempting to generate profit for their shareholders to the detriment of their own business, Lothar Reinhardt decided to keep the business in the family. It was a decision that made a great deal of sense for a man steeped in old-world tradition. Reinhardt was known to offer toasts to the Fatherland at banquets. His home at 469 Jarvis Street in Toronto was known as Linderhof and featured two stone lions sculpted to match the design of those outside the palace of King Ludwig of Bavaria. His daughter, Amanda Reinhardt, studied music at Leipzig before marrying Captain Freiherr Robert Wurl Von Senten and becoming a minor baroness.

LOST BREWERIES OF TORONTO

All four of Lothar Reinhardt's sons found themselves in the brewery business as soon as they were old enough to work. Lothar himself would remain the president of the company, while Arthur ran the day-to-day affairs of the brewery on Mark Street. Alphonso would be the brew master at Mark Street, although he would be temporarily spelled by his younger brother Ernest when he went to Chicago to complete his training at a brewing school. Formal education was clearly important to Lothar Reinhardt. He sent his eldest son, Lothar Jr., to a separate brewing school in New York.

In 1899, Lothar Reinhardt Jr. married Carrie Evelyn Davies, the daughter of Robert T. Davies of the Dominion Brewery. After a brief honeymoon, the young couple relocated to Montreal for the purpose of running the newly established Salvador Brewery in that city. The brewery had been newly constructed and featured an artesian well, state-of-the-art refrigeration and filtration technology and a storage capacity of 1 million gallons. The Salvador Brewery could produce 115,000 barrels of beer annually. The Montreal plant didn't stop at producing lager but branched into ale and Porter as well. To cut down on any time lost in acclimatizing to the new territory, the Reinhardts simply put the man who had been their business agent in Montreal in charge of representation.

By 1908, the Salvador Brewery in Montreal had failed and was purchased by Imperial Breweries Limited, becoming part of National Breweries the next year. Lothar Reinhardt passed away in 1915, leaving an estate worth nearly $250,000. The East End Brewery languished during prohibition and was damaged badly by a fire in 1924. It was purchased in 1926 by a consortium from Detroit. The members had difficulty in securing a license to produce beer, and the company was sold in 1927 to a Toronto group headed by John S.G. Cornnell, a man who in terms of the continued business of breweries in Toronto was a walking calamity.

Old Chum Lager Beer demonstrates the profound influence the horsey set had on the brewing industry in Toronto in the wake of the intermarriage of the mercantile families. The mascot wears the clothing of the master of the hunt. *Molson Archive.*

Having incorporated in April, the brewery was shut down within five months for "flagrant bootlegging." The Ontario Liquor Control Board's dubious solution to the problem was effected by removing from the brewery the entire supply of crown stoppers so that no bottles could be sealed for shipment. In an interview, Cornnell stated that the brewery did not accept responsibility for the allegations and that they had not been able to get to the bottom of the problem.

With J.E. Davies at the helm, the brewery improved drastically. He had had significant experience at the Davies, Copland and Brading Breweries. The

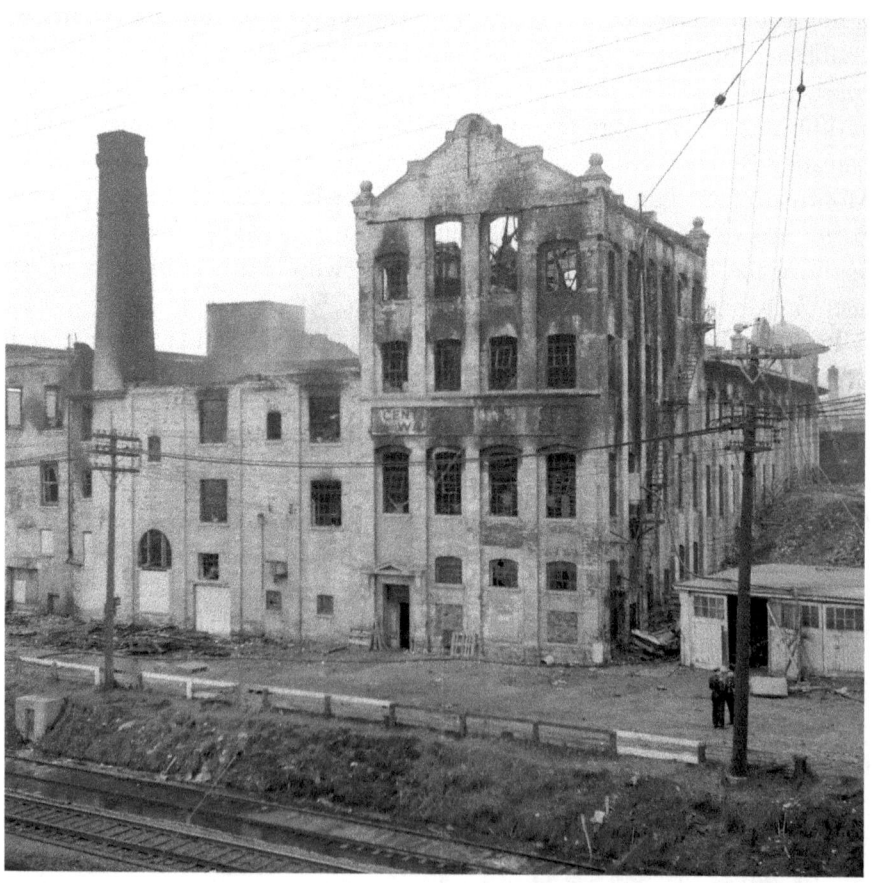

This image from 1957 shows the burned-out husk of the East End Brewery. The section on the right would have been built by Reinhardt after 1888. The section at the left, with the smokestack, is more likely to be the original building erected by Robert Defries. *Toronto Public Library.*

White Horse Ale was one of two post-prohibition brands from the Reinhardt Brewery in Toronto. It's hard to suggest anything about what the beer might have been like due to the dearth of information on the label. After prohibition, packaging was frequently more important than content. *Molson Archive.*

dual brands that they produced reflected the Davies family's pronounced interest in matters equestrian. Old Chum Lager features a genial-looking man dressed in the manner of the master of a foxhunt. White Horse Ale is obviously conceptually linked.

By 1937, the company had gone public on the Toronto Stock Exchange and was even managing to pay dividends. The increase in price was in part due to the fact that E.P. Taylor had been acting surreptitiously to acquire majority control. As was typical of E.P. Taylor's business model, the East End Brewery was made part of a consolidation of Canadian Breweries' subsidiary companies, becoming the Cosgrave Dominion Brewery before burning down in 1957.

Chapter 12

WILLIAM COPLAND BREWERIES, 1830–1946

William Copland came to Upper Canada in 1830 and promptly embarked on a career as a brewer. His first brewery would have been on Yonge Street. What is known is that he came equipped with the experience necessary to start up. In his native Norfolk, Copland had been a miller and dealer in grain at Holt. The business did not treat him or his family well. In 1822, he filed for bankruptcy just a few short years after taking over the business from his brother, Samuel. Samuel had gone bankrupt running the same mill. When he left England with his family, he had the mill placed in a deed of assignment and didn't look back.

Oddly, we know less of William Copland's early brewing career than we do of his opinions and politics. His brother had a relationship with a publishing house in London, and William Copland's letters were reworked into a narrative of the early days of the Upper Canadian rebellion. The account relates that his sons, Charles and William, spent the night of December 4, 1837, casting bullets for their pistols and muskets at their brewery just south of the first concession road. William Copland did not think much of the rebels and their hotheaded leader, but he took the threat seriously. At first light, they packed up the valuables and headed into York proper.

By 1847, Copland had founded a brewery on the oddly shaped block to the northeast of Front and Parliament Streets. Taddle Creek ran through the property, which was just upstream of Enoch Turner's Brewery and Distillery. The land was owned by the Trinity Church, of which Turner was a trustee. Copland had to relocate at least once in the period between starting up as

Lost Breweries of Toronto

Copland's East Toronto Brewery was more or less defined by the shape of the block it occupied near Parliament and Front. The buildings created a courtyard and a sense of enclosure. *From* Timperlake's Illustrated Toronto.

a brewer and coming to rest in this permanent location. The previous year, he had been on Queen Street West. In 1847, he was sixty-two years old, but luckily he had the assistance of his son, who was also named William. The younger William was already forty years old.

William Copland passed away in 1862, and the brewery was taken over by his son. The younger William Copland would make a number of improvements to the structure over the next twenty years, but he would also inadvertently limit its lifespan. The leases on which the property was dependent were renewed in the late 1870s on comparatively short terms. That did not stop the expansion. By 1866, he was producing 20,000 bushels of malt per year and brewing approximately 11,500 barrels. Eventually, the brewery became too much for Copland to handle, and in 1882, he sold to a partnership that had previously worked for the Toronto Brewing and Malting Company. Copland would pass away in Santa Barbara, California, while undergoing a rest cure at the age of eighty.

In the late nineteenth century, it was no longer tenable for a brewery to be family owned. There were too many risks from the point of view of legacy planning, and there was too much work for one man to oversee. The partnership that had assumed control would retain the Copland brand and style itself the Copland Brewing & Malting Company. The president was Humphrey Lloyd Hime, who was noted for his photography in 1858 of the native peoples of the Red River settlement and his subsequent rise to

This image purports to be of the Copland East Toronto Brewery, circa 1861. The low-slung wooden buildings created an internal courtyard, which could be used for stabling and storage of casks. *Toronto Public Library.*

the chair of the Toronto Stock Exchange. The brewer would be William Haldane, who had come to Canada from Scotland, and his son, Hudson Coldwell Haldane, would be his assistant.

In 1884, Charles Pelham Mulvany wrote of the men who had acquired the brewery that "[t]hey are men of untiring zeal and energy, great popularity, and of thoroughly practical experience, acquired by many long years devoted to the trade." In the two years that passed between their acquisition and his description, they had greatly enlarged the premises and nearly doubled the trade of the business. The five-acre brewery had the largest vaults in the city and three icehouses. The fire insurance map of 1880 suggests that the brewery was fitted with dual steam engines for the brew house boiler. The ingredients were of the highest quality, with special consignments of hops shipped from Bavaria. The selection of beers on offer, traditional ales

and a brown stout, were not terribly exciting but were made by a quality brewer. Mulvany believed that William Haldane "is a gentleman who has few rivals in his line, not only in America but in the world. This is something to say of a Canadian brewer, but ability, pluck, and enterprise combined can accomplish all things."

Meanwhile, not very far away at the intersection of King and Ontario Streets, a new business had started up under the name Queen City Malting. It lasted two years under that name prior to becoming the Ontario Brewing and Malting Company in 1884. The company was run by a tightknit group associated with the Taylor family, who had made their fortunes in the paper business above Todmorden on the Don River. Thomas Bright Taylor, the vice-president, was actually William Helliwell's nephew. Fortunately, Mulvany was on hand to provide the details of the competition as well.

It's clear that the Ontario Brewing and Malting Company emphasised the malting portion of its business. While the brewery was a solid square structure of 125 by 125 feet, it only had two tanks with four-thousand-gallon capacities. While that may sound like a lot, on a year-round brewing schedule a generous estimation would put their capacity at twenty thousand barrels. The real strength was the malt house and grain elevator. The grain elevator was 120 by 45 feet and seven storeys tall. It was made of corrugated iron and was entirely fireproof. It had the ability to store 200,000 bushels or about 6.8 million pounds of grain. The malt house employed fifty men and could malt 300,000 bushels per year. In 1883, the year before the rebranding, the company sent 216,000 bushels of malt to the United States. The company had issued $250,000 in capital stock. The facility was state of the art.

It had become the case in England that businessmen were having some difficulty finding ventures in which to invest their money. In many cases, they approached breweries in Ontario to determine whether they'd be interested

The majority of the breweries in Toronto did business with Rolph Smith and Company for its labels. While the concept of a pale ale may not be particularly exciting, note the flow of the ribbon incorporated through the design. It's an elegant touch. *Molson Archive.*

This label dates from the brief period when the Ontario Brewing and Malting Company and Davies Brewery were owned by an English consortium, which renamed its combine Ontario Breweries Limited. The Crown and St. George's cross are dead giveaways. *Molson Archive.*

in selling. The Ontario Brewing and Malting Company was, but it wasn't the only one. It was amalgamated under the banner of an English consortium as Ontario Breweries Limited in 1891. Other companies that were involved were the Davies Brewing and Malting Company, operating out of the Don Brewery, and Peter Grant and Sons' Brewery in Hamilton. The Taylors had made a mint on the sale.

Things were not going as well at the Copland Brewing Company down the street. The partnership that had been praised so highly was dissolving after only a decade. In September 1892, H.L. Hime was attempting to liquidate all of the equipment that had been brought in to update the old facility. It remained on the market for a year and a half before it was purchased by Thomas Bright Taylor. Taylor would bring the expertise of a more modern facility to bear on the smaller brewery and create a new roster of brands. An India pale ale and a stout were to be expected given the market of the time, but there was also royal export ale and Budweiser lager.

Coverage of the Copland Brewing Company in the *Globe* in 1899 was stellar. From the level of detail that was provided, we know that it

As the nineteenth century came to an end, breweries were interested in making their products more eye-catching to the public. While it would have been standard to make an ale and a Porter, the newness of the India pale ale style is highlighted by the curlicue fonts and shield-shaped badge. *Molson Archive.*

would have been recognizable as a modern brewery, despite having a carpenter shop and cooperage. Its wort chiller employed superchilled brine in place of water, and the fermentation vats for ales were steel enameled. Processes for filtration and checks for clarity were in place to ensure the quality of the product. Ale would have been aged for six months, as was the style at the time. Lager was produced much more quickly. A reporter stressed the cleanliness of the operation; the scalding of barrels and jets of gas ensured a clean interior. The brewery stables required eighteen draught horses just to keep up with delivery in the city.

The quality of the horses would have been excellent. Thomas Bright Taylor's family owned Thorncliffe, and his stepbrother, George, raised horses on the property. The entire family took on a sporting bent. From 1897, the employees of the Copland Brewing Company were treated to an annual sports day in late summer, which was typically held at the Woodbine racetrack east of the city on Kingston Road. There were the traditional picnic games but also athletic contests serious enough to be covered by the newspapers of the day.

Ontario Breweries Limited, for all its foreign capital, was a concept that was ahead of its time. Brewery consortiums would prove to play a significant role in brewing in the wake of prohibition, but the conditions were very different by the 1930s. The brewery industry in Ontario in the 1890s suffered as a result of the newly enforced McKinley tariff in the United States that shrank the exports of malt and reduced profits across the board for those who produced it.

The malting capacity that had been a great strength for the Ontario Brewing and Malting Company became something of an irrelevance without foreign buyers, as most breweries maintained their own maltings. Add to this

the fact that the already stressed Toronto water system had raised its prices, and suddenly malt was very expensive to produce. Toronto maltsters of the time claimed that they could no longer compete with Hamilton on price.

In 1900, the English consortium disbanded due to the deaths of some of its members and attempted to sell off both the Ontario Brewing and Malting Company and the Davies Brewing and Malting Company. While the Copland Brewing Company was doing well at its Parliament Street location, the leases that it held with Little Trinity Church were due to run out in short order. Additionally, Thomas Bright Taylor had been the vice-president of the Ontario Brewing and Malting Company and would have appreciated that the facility was of better construction than the Copland Brewing Company and that it had more room for expansion. Fully half of the land on which the Ontario Brewing and Malting Company sat at King and Ontario Streets was empty.

In 1901, Thomas Bright Taylor purchased the Ontario Brewing and Malting Company. The brand, due to the efforts of the consortium, was of practically no value. The Copland brand had gone from strength to strength under Taylor's leadership. The decision to consolidate Copland's production at the Ontario Brewing and Malting Company plant cannot have been a difficult one. After all, the distance between the breweries was only two hundred meters.

In 1903, the company was restructured as a partnership, although it's clear that the decision was made to keep the brewery more or less within the family. The partners consisted of Thomas Bright Taylor and a number of the Davies clan. Thomas's elder stepbrother, George Taylor, had a daughter who married Robert T. Davies—the man who owned the Dominion Brewery on Queen Street. Robert W. Davies, whose name would come to be associated with the Copland Brewing Company Limited, was Thomas Bright Taylor's great-nephew.

The company continued under Robert W. Davies to prohibition. It never lost the sporting accent that it had acquired under Taylor. It published a kind of sports almanac, the *Vest Pocket Reference Annual*, right into prohibition. As happened with many brewery enterprises, the facility degraded somewhat when it was forced to produce lighter products like Special Brewed Ale, which was marketed not merely for its freedom from alcohol but also for its lack of carbonation. The facility closed in 1916.

William Copland's 1838 narrative on the rebellion proved nearly a century later to be prescient: "The Yankees are still holding meetings and raising money and men for future operations against us; but theirs is a free country,

Left: When Copland's was taken over in 1927 by the William Simon organization from Buffalo, many of the brands produced by the brewery were adorned with the "Simon Pure" trademark and flying hop logo. These were removed when nationalism struck during the Second World War. *Molson Archive.*

Right: Copland Red Ribbon was brewed after prohibition but prior to the Labatt takeover. The inclusion of rice in the recipe is a clear indication of the influence that Budweiser and other American lagers had had on the Ontario market. *Molson Archive.*

and the laws are obeyed only when it suits their convenience or interest." In 1927, with the repeal of prohibition in Ontario, the Copland Brewing Company fell into American hands.

The William Simon Brewery in Buffalo was not able to operate under the conditions of the Volstead Act, which would continue to hamper any legitimate production of alcohol in the United States until 1933. With capital available, it made a great deal of sense for the owners of William Simon to purchase a brewery in Toronto. For one thing, Toronto was a much larger market than Buffalo, and the ability to sell across the province of Ontario must have been tempting to a company that had not been able to produce beer for several years. Additionally, there was the advantageous prospect of being able to flood the American market with beer immediately after prohibition was repealed. It had happened in Canada, so the assumption that the same decision would come to America was a good one.

The brewery had fallen into some disrepair, and it would take the first half of 1928 to render it fit for operation. The issue of twenty thousand shares of stock in 1929 was optimistic. It stated that production would close in on twenty thousand barrels for the year beginning on June 1, 1928. They believed that they would realize a profit of $100,000 in the first year. The

combined strength of the Copland name and the William Simon "Simon Pure" trademark was considerable.

William Copland would have been gratified by the mood following the World War II. A sense of national pride swept the country. It was no longer fashionable to drink beer brewed in Canada by an American company. The Copland Brewing Company had a solution to that. Its brewmaster, Pat Wismer, had been awarded the Distinguished Conduct Medal in World War I after capturing a machine gun nest and taking seven Germans prisoner. The French government awarded him the Croix de Guerre. For a brief time, Copland released Pat's Stock Ale, the label of which not only featured

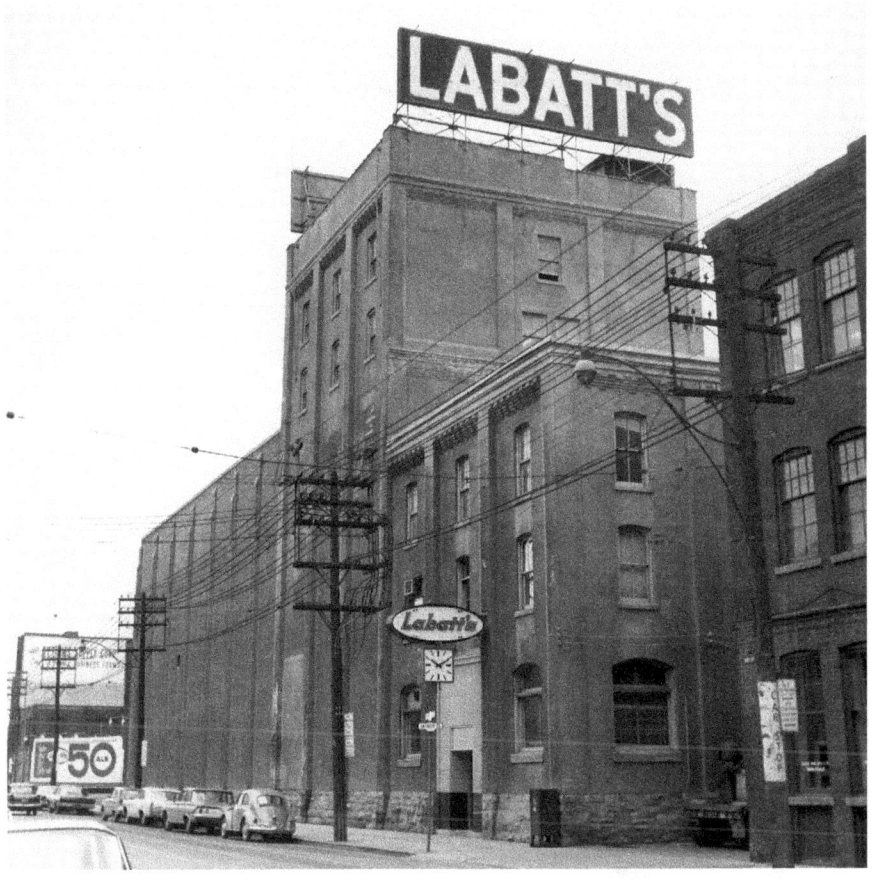

The Ontario Brewing and Malting Company operated under the Copland name until 1947, at which point Labatt purchased the plant. It stood at King and Ontario and was eventually replaced by the offices of the *Toronto Sun*. *University of Western Ontario.*

a maple leaf, the Union Jack and Ontario's Red Ensign but also the text "made by 100% Canadians."

In June 1946, Labatt purchased the Copland Brewery. It made a good deal of sense as it had become a publicly traded company in 1945, issuing 900,000 shares of stock to raise capital. The Copland Brewery was one of very few in Toronto that had not been swallowed up by E.P. Taylor's Canadian Breweries. By October, the production of the brewery had doubled, and beer ceased being produced under the Copland Brand.

The properties that housed the Copland Brewery over the years are fairly easily recognizable. The original site of the Copland Brewery would have been a spring that fed Moss Park Creek, which is now buried as a series of narrow parks just east of Yonge Street and south of Bloor. The East Toronto Brewery is now the Toronto Police Service's 51 Division. The Ontario Brewing and Malting Company is now occupied by the offices of the *Toronto Sun*.

Chapter 13

COSGRAVE BREWERY, 1844–1960S

The West Toronto Brewery was located on the southwest of Queen and Niagara Streets, directly across the ravine from John Farr's Brewery and across the street from Trinity College. It was built in 1844 and was originally a business venture on the part of Thomas Baines. Baines was not formally trained as a brewer but may have picked it up from a colleague in his early professional life. He worked with Peter Robinson as a land and immigrant agent on the settlement of the Irish in Peterborough. Robinson was a relatively well-known brewer in Newmarket in the 1820s and '30s.

Baines came to Canada in 1821, and brewing was not his first career. Even while he owned the brewery, he had other employment. He was deputy auditor general for Upper Canada before being put in charge of the sale of the Clergy Reserves. He would eventually find himself the Crown's land agent for the Home District, which stretched from Lake Ontario to Lake Simcoe. It is unlikely that Baines was personally involved with the running of the brewery, leaving that to his partner, Isaac Thompson.

Baines resigned his commission as land agent in 1855 following the realization that he had created the single largest default in Upper Canada's short history. The ruling in 1859 found that £30,000 of the public's money had been either embezzled or lost through misadventure. The verdict handed down was that all Baines's property was to be seized. Fortunately, Baines had parted ways with Isaac Thompson in 1857 through a dissolution of their partnership.

Lost Breweries of Toronto

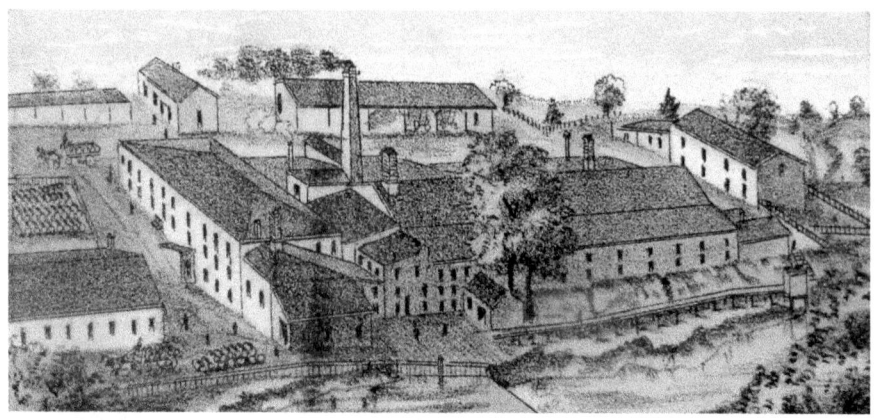

This is an image of the Cosgrave West Toronto Brewery as seen from approximately the roof of the Farr Brewery across the ravine. Note the impressive width of Garrison Creek in the foreground, dating the sketch to the 1870s. *From* Timperlake's Illustrated Toronto.

Thompson would have been the brewer on a day-to-day basis anyway. Even in the dissolution notice, there were hints that he was the one running the sales side of the business. He was selling beer in partnership with his brother, Charles, through a series of grocery stores and the East India House. Thompson spent most of the time that he owned the brewery, between 1857 and 1863, making upgrades that he felt were needed.

In 1863, the West Toronto Brewery was taken over by the partnership of Charles Sproatt and Patrick Cosgrave. Of all the brewers in Toronto, Patrick Cosgrave had the longest road to independence. His first brewery had been located on the Credit River in Etobicoke and had existed as a partnership with John Moss. The brewery had plenty of access to water and barley, but the majority of the beer-drinking population lived in Toronto. For an ambitious brewer, the location was a nonstarter. Moss must have felt the same way, as he ended up a scant hundred meters away running John Farr's brewery in the 1860s.

Ambition was a key factor in Patrick Cosgrave's early years in Toronto. He had, at least according to his obituary, arrived in Toronto with scarcely a dollar in his pocket. He had eventually found himself as a salesman for the Aldwell-leased Victoria Brewery before partnering with Eugene O'Keefe to lease the property and commence brewing for himself. The partnership, beginning in 1861, lasted only two years but resulted in a threefold return of the initial investment, allowing Cosgrave some freedom to find his own

Left: Cosgrave, throughout its existence, experienced some real problems with branding. It developed in several different directions, but one of the longest lived was the elk and horseshoe combination. *Molson Archive.*

Right: The combination of the diamond shape and corkscrew is an early development for the Cosgrave branding. The Pale XXX Ale name would be abandoned by the time India pale ale became the more popular designation in the 1890s. *Molson Archive.*

venture. His partnership with Sproatt would last about four years, until Sproatt moved to the Spadina Brewery.

From the beginning, the Cosgrave Brewery had been a family affair. Patrick Cosgrave employed both of his sons, John and Lawrence, in the running of the brewery and his nephew, James, in the management and bookkeeping side of the enterprise. Between 1867 and 1879, the brewery was built up considerably, developing the capacity to malt seventy thousand bushels per year and brew sixty thousand barrels, split between two separate facilities. Cosgrave had won medals for its pale ale in the 1870s at two consecutive world's fairs in Philadelphia and Paris and twenty-five thousand barrels was set aside for its deservedly popular ale. Thirty-five thousand barrels of capacity was designated for lager, and by 1879, Cosgrave had taken to producing a Vienna lager.

The same year, a fire raged through the original brewery building, completely destroying it. All that was left were the lager brewery and the malt house. There had been plans in place to replace the ale brewery with

a more modern structure in any event, but this development ensured that the new building to be constructed would be fireproof. The choice had to be made whether in the short term to continue to produce ale or lager in the remaining building. It was a difficult choice for the reason that the Toronto market was suddenly flooded with lager thanks to Lothar Reinhardt at the Walz brewery and Eugene O'Keefe's new facility. A meeting of the victuallers association established a maximum price that members would be willing to pay for lager at wholesale; this price would have constituted a loss in revenue at a time when the brewery was attempting to expand. Cosgrave's would abandon lager for the time being, settling on the decision to become the sole licensed importers of Valentin Blatz's lager from Milwaukee in 1889.

Patrick Cosgrave passed away in 1881 at the age of sixty-four. His sons, John and Lawrence, would form a new corporation under the name the Cosgrave Brewing and Malting Company. John Cosgrave was mostly interested in commercial expansion into the Northwest Territories and sat on the Toronto Board of Trade. Lawrence was more suited to the business of brewing, and the 1882 decision to focus on the extra stout and India pale ale was his. His rationale was that "[n]ecessity will no longer exist for importing foreign Ales and Porter, as our patrons CAN DEPEND upon us furnishing an article equal to Bass or Guinness at a much less cost. Warranted PURE and healthful. FREE FROM ALL DELETERIOUS SUBSTANCES."

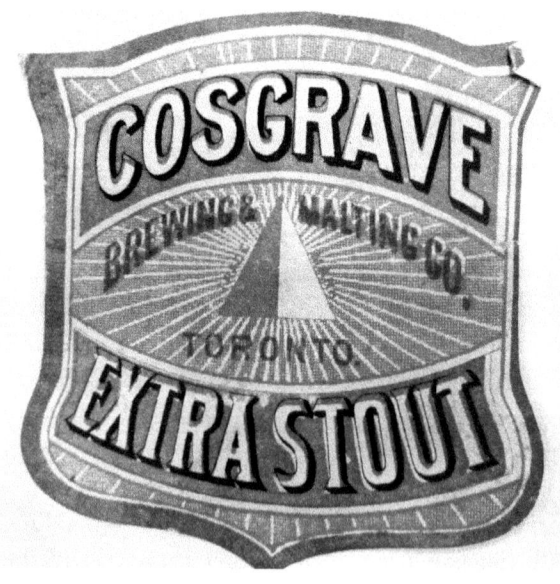

The trademark employed on this badge-shaped label for Cosgrave's Extra Stout is a bisected triangle, perhaps emulating the legendary Bass mark. *Molson Archive.*

LOST BREWERIES OF TORONTO

Lawrence Cosgrave was a formidable athlete (for a time the Royal Canadian Yacht Club had a Cosgrave Cup), and unlike many of the brewers, who used the recommendation of doctors on their product labelling, he had actually made a personal study of nutrition and believed in the power of beer to promote health in moderation. From the *Daily Mail and Empire* in 1898:

> *I have always looked upon malt liquors as a food product, and those who object to their use have not a proper understanding of this article. These individuals undoubtedly daily use milk, but consider malt liquors injurious. Malt liquors, brewed in a right manner, and of proper material, are a far more healthy and tissue-making drink than milk...I am endorsed by some of the greatest physicians in the world in my opinion that the ladies would enjoy much better health in this country if they used good beer in the same way as they use milk.*

Under his vigorous management, the size of the brewery that had burnt in 1878 was quadrupled, and by the turn of the century, the overall capacity had been expanded to 100,000 barrels. Lawrence Cosgrave had an important managerial skill: the ability to hire good people and get out of their way. The brewer was Charles Hodgson, who had worked his way up from a role as an apprentice in 1882. The maltster was Charles Thomas, who had acquired some thirty-five years of experience in malt houses around Toronto, including Copland's. James Cosgrave, Lawrence's cousin, acted as secretary and treasurer and began quietly purchasing interests in Toronto's licensed hotels as the Scott Act came into play in the 1890s.

The brewery's other great strength was its bottling facility. While many breweries in the Toronto area focused on licensee sales, the Cosgrave Brewery had a world-class bottling facility and exported its beer to destinations as remote as Australia, South Africa and the West Indies. Accounts from the period agree on the sheer volume being sold in this method, the brewery keeping 120,000 bottles on hand at any given time. The bottling room was separate from the racking cellar by three hundred feet and was supplied by means of a specialized pump that John and Lawrence Cosgrave had invented in 1879. The bottle filler could manage 10 bottles simultaneously. The brewery could package 7,200 bottles per day. The supply of beer came from the capacious 150,000-gallon cellars.

Under Lawrence Cosgrave, the brewery performed so well that when the malt house was struck by a fire begun in the malt kiln in 1904, wiping

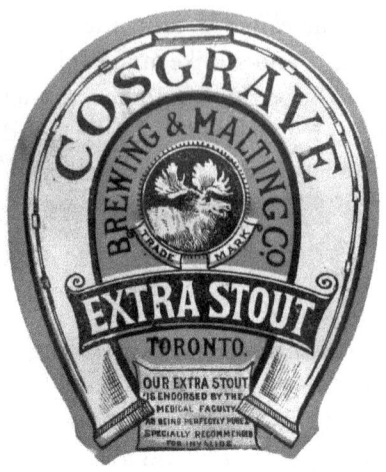 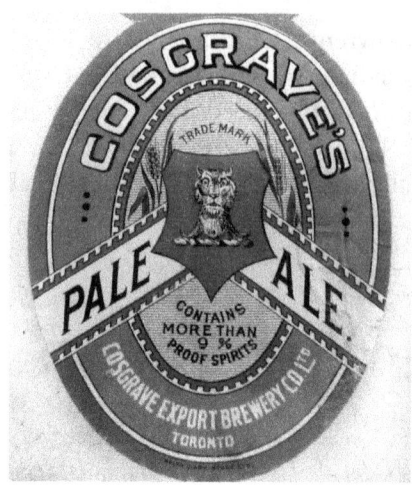

Left: Cosgrave's extra stout was, like many stouts of the day, endorsed by medical specialists. The combination in branding in use at the time is a bull moose and horseshoe. It is a better pub name than a trademark. *Molson Archive.*

Right: By the time it became the Cosgrave Export Brewery Company Limited, the mascot for the Cosgrave concern had switched to a rather stunned-looking tiger. The brewery produced a pale ale, a Porter and a blend of those two products creatively called Half and Half. *Molson Archive.*

out the cooling equipment, fermenters and mill, he simply purchased the languishing Toronto Brewing and Malting Company. The Cosgraves would own the facility until the 1920s, operating it during prohibition as the Toronto Vinegar Company.

The third generation of the family running the brewery shared their father's sporting outlook on life. James F. Cosgrave would be the face of the business, joining the company in 1906 and becoming president and general manager in 1910. James was considered at one time to be the finest sculler in his weight class in Canada. His brother, Lawrence Moore Cosgrave, worked briefly at the brewery as teenager but did not enter the family business significantly, embarking on a military career instead. He was a graduate of the Royal Military College in Kingston and won the Distinguished Service Order twice during the First World War. He was much publicized for that and for successfully proposing marriage to his childhood sweetheart from his position in the trenches. He was the Canadian representative for the signing of the Japanese Instrument of Surrender at the end of the Second World War.

The Cosgrave Export Brewery was incorporated in 1922 and did a modest trade in the 2.5 percent and 4.4 percent proof spirit beer that was allowed to the public prior to 1927, but that's not to suggest that they were not also doing a solid business in regular-strength beers. Shipments of 150 cases were known to wash up from time to time on the public beach outside Rochester, New York. People were frequently fined for driving away from the brewery with cases of over-strength beer. Many hotels around Toronto were shocked to learn that instead of the low-alcohol temperance beer, they were stocking regular-strength beer. Despite their protestations of non-complicity, they seemed to serve the stronger stuff to people requesting "good beer."

The Cosgrave Export Brewery was frequently fined for its transgressions, but realistically there was no punitive amount that would dissuade it. In April 1927, it came out that James F. Cosgrave had been using a very basic bureaucratic loophole to supply Toronto hotels with strong beer for just over four years. Toronto hotels were disallowed from ordering any product over 4.4 percent proof spirits. Orders for export were a different story.

Orders received from the United States were technically legal, although under the Volstead Act it would have been quite difficult to get any beer across the border. The solution was that Toronto hotels would phone a proxy in the United States who would place the order. A truck would arrive at the brewery and take the beer away. Because Cosgrave did not own the trucks, he pleaded ignorance as to their destinations. Payment was also accepted through a proxy. When asked if he was surprised that the B-13 customs forms were never returned to the brewery, he stated, "We presumed they would come back in time." Since they had paid the taxes, no significant punishment was rendered despite their reputation as the "most flagrant violators of the Ontario Temperance Act."

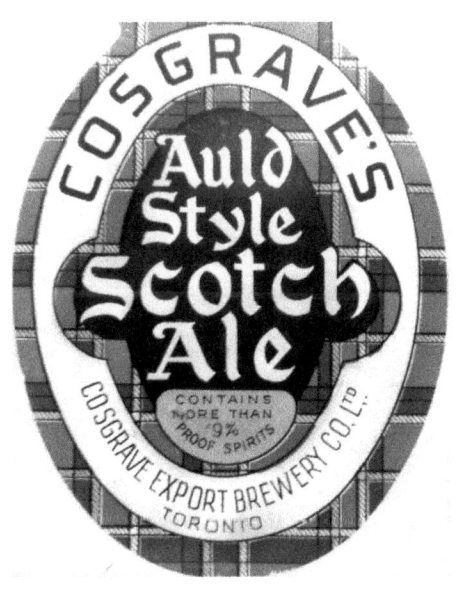

Cosgrave was the only brewer in Toronto to produce a Scotch ale after prohibition. The taste had switched dramatically from ale to lager as a result of American influence and several decades of temperance movements. *Molson Archive.*

In 1934, E.P. Taylor's Canadian Breweries bought out the Cosgrave-owned West Toronto Brewery and kept James F. Cosgrave on board as his vice-president, leaving him in charge of the plant. There may have been a grudging respect for the hard-nosed approach that James had used in the latter days of the Ontario Temperance Act. It may have been his keen interest in horse racing, which Taylor shared. Cosgrave retired in 1939 to start up his own very successful racing team. The Cosgrave Brewery would survive until the 1960s under E.P. Taylor's watchful eye before being demolished as redundant to his empire. It was briefly replaced by a location of Brewer's Retail in the 1970s.

Chapter 14

O'KEEFE BREWERY, 1840–1960S

There's very little known about the early days of the Victoria Brewery. It was located at the southwest corner of Victoria and Gould, a scant block north of what is now Dundas Square. It is claimed that the brewery was established in 1840 at 30 Richmond Street, but if it was, it made such little impact that there is no record of it in the city directories of the time. It was probably moved to the Victoria and Gould location by Charles Hannath and George Hart in 1849. While Hannath was a brewer by trade, he did not retain control of the business for very long. In the early 1850s, the Aldwell brothers had the lease on the property.

The brewery was not particularly large or well appointed. There were drainage problems significant enough that the Aldwell brothers moved to a new facility of their own design at the first possibility. They had been leasing from Hannath and Hart, who now needed to find new tenants. It's possible that the brewery would have languished, but the partnership of George Hawke, Patrick Cosgrave and Eugene O'Keefe was waiting in the wings. It was a unique partnership in largely Protestant Toronto for the reason that all of the members were Irish Roman Catholics. They took over the Victoria Brewery in 1861.

It can't be claimed that they took over the brewery in working order. The first advertisements in the newspaper were not for the sale of beer but rather tenders for basic equipment: a boiler, an engine and stabling large enough for three horses. With all of these problems, the brewery was producing something like eight thousand barrels of beer per year. Things went so

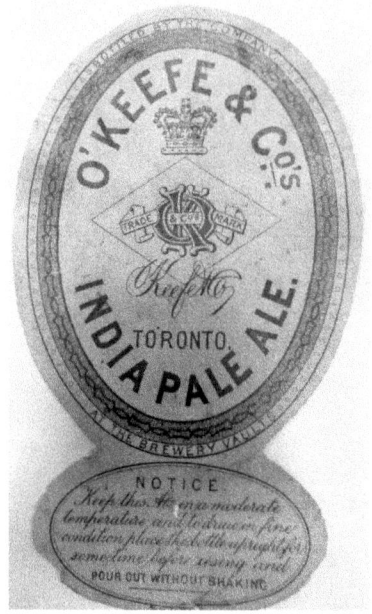

Left: This label for O'Keefe's India Pale dates from before 1891 and gives some indication that the product was bottle conditioned for carbonation. The instructions suggest that you let the bottle stand and then pour without shaking. Good advice. *Molson Archive.*

Below: The O'Keefe Brewery Company's letterhead gives a sense of the scale of the O'Keefe Brewery. The view here is from the northeast corner of Victoria and Gould Streets. It is now the Ryerson University Campus Store. *Thomas Fisher Rare Book Library.*

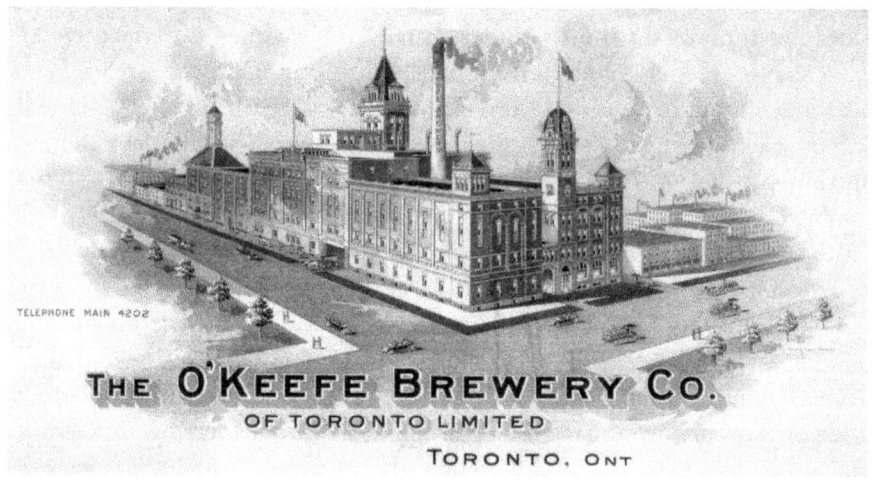

badly that Cosgrave left the partnership in April 1863, and it was renamed O'Keefe and Company. It's hard to blame him. At the time, it must not have seemed worth the bother.

In early 1864, it became apparent that the brewery's water supply was going to be cut off. The water supply depended in part on the Yorkville Reservoir, which was losing the city one thousand pounds per year and

whose contract was unlikely to be renewed. Faced with calamity, O'Keefe was pragmatic, a trait that would persist throughout his career. While clearly engaging in self-preservation (breweries require staggering amounts of water), his letter to the *Globe* took a public-spirited approach:

> *It is a matter that calls for the immediate action of the public. As no intimation has before been given, we beg to remark that a large portion of the city will soon be deprived of one of the greatest necessities of life, and subject to great inconvenience and peril—first, by the deprivation of water, and the consequent great increase in the rates of insurance; and secondly, by the great chances of fires that will inevitably occur, should such a contingency as we have noted take place.*

While this could easily have been seen as a cynical manipulation, O'Keefe's character over the length of his career makes it clear that this is not the case. While Eugene O'Keefe did not compromise the success of his business or his personal success, he realized that he was a part of a larger society. Whether it had to do with his deeply held religious beliefs, a sense of civic-mindedness or even basic give-and-take pragmatism, he would typically attempt to do his best for the society around him. He was both well meaning and calculating, an admirable combination.

As a case in point, take the donation on June 6, 1866, of two hundred gallons of ale to the garrison at Fort Erie. Four days prior, Fort Erie had found itself briefly occupied during the Fenian Raids. The majority of the Fenians had surrendered to the Americans in New York State. The gesture accomplished a number of things. At its most basic level, it was a gallant show of patriotism. It additionally separated in the minds of the public O'Keefe (himself a moderate Irish nationalist) from the extremist Fenians. Further, it promoted the brewery. It was beneficial for all parties involved.

Under O'Keefe and Hawke, the brewery expanded rapidly. By 1868, they had been kitted out with an entirely new set of machinery, obviously a necessity given the state of the brewery in 1863. Not only had they purchased a twenty-five-horsepower engine and boiler, but they were also contemplating an expansion for increased fermentation, cellarage and cooling. The expansion would allow them two thousand gallons of production per day, or about twenty-three thousand barrels per year. Most impressive is the variety of hops being used. In addition to locally sourced hops from Ontario, O'Keefe and Company were using Bavarian, Belgian, Mid Kent, Worcester and Wisconda hops.

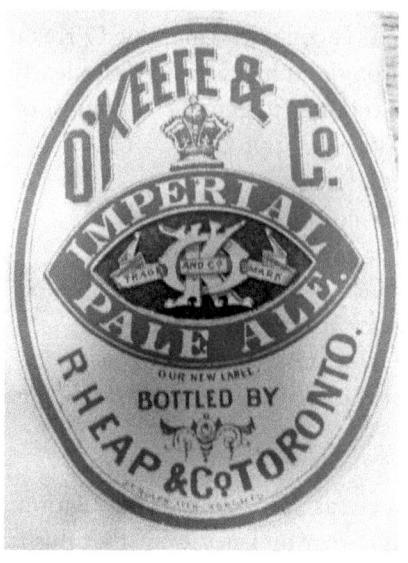

The O'Keefe Brewery relabeled all of its beers using the term "Imperial" at some point after the brewery was expanded in the late 1870s. There's no indication that they were a great deal stronger than they had been previously. *Molson Archive.*

After the renovation, the brewery contained five fermenting vats of 4,000 gallons each and "an immense copper refrigerator for summer use," which was the first of its kind in the province. The dual three-floor malt houses were each thirty feet wide. One was one hundred feet long and the other sixty. The larger of the malt houses had a kiln that was eight hundred feet square. It was able to malt forty thousand bushels a year for its own purposes and sold the excess only when it was convenient. The icehouse had a capacity of 250 tons, which was enough to keep the 180,000-gallon vault beneath the brewery at a reasonable storage temperature during the summer. By this point in 1871, it was already exporting its stock ale to New York and Chicago, despite a nearly 80 percent duty on imports. This may have been the result of its policy of sending free samples of the product to hoteliers and bottlers throughout the Dominion and the United States. It had tripled its business in eight years.

It may seem miraculous that a small brewery with severe problems should have been able to accomplish that amount. John Aldwell, the previous tenant of the brewery, did not lack for ambition either. What he did not have was a close association with the Toronto Savings Bank. O'Keefe had been a clerk at the bank prior to becoming a brewer and remained affiliated at the highest levels throughout his career. He would continue to expand the brewery indefinitely for the reason that he had unfettered access to the capital to do so.

In 1879, O'Keefe became the second brewer in Toronto to produce lager. The introduction was as much about moving the product as it was about improving the society. The following somewhat contradictory paragraphs from the same full-page advertisement heralding the product launch display O'Keefe's combined motivations:

LOST BREWERIES OF TORONTO

The Lager and "Pilsener" brewed by Messrs. O'Keefe and Co. are pronounced equal to the best on the continent of Europe. The hops used in those beers are from Nuremburg, Bavaria, and are imported directly by the firm. The malt is prepared specially at their malt houses by a process different from that of any other in this country, and the article produced my justly be styled the "CHAMPAGNE OF MALT!"

Messrs. O'Keefe and Co. contend that the benefits accruing to the country by the introduction of first class malt beverages cannot be over-estimated and will tend more to the interests of TEMPERANCE than all the legal enactments and repressive measures that any Government may introduce... Coming nearer to home, we find in the United States of America a PEACEFUL REVOLUTION going on in the drinking habits of the people. This is particularly noticeable in the large centres, such as New York, Cincinnati, Philadelphia, Milwaukee, Chicago and Buffalo. In the latter city the change in the last ten years is truly marvellous, a High Church dignitary of that place stating "that the next greatest blessing there after the advent of religion was the introduction of Lager Beer, as it completely weaned the people, particularly the working classes, from the use of stronger beverages."

O'Keefe was not a believer in the prohibition of alcohol, but he was a proponent of temperance in his way. It may seem ludicrous, but his position is highly congruent. While he was certainly very wealthy, an Irish Roman Catholic in Toronto was very much a minority. The working classes mentioned were O'Keefe's people: first- and second-generation Irish immigrants who were ruining themselves on cheap whiskey. O'Keefe knew that prohibition would only create illicit markets and additional suffering. If people were going to drink, then lessening the sin of doing so was a noble calling.

Some people naturally assumed that this was an act, and Eugene O'Keefe had a sense of humour about it. While being cross-examined on the issue of prohibition in 1893, he was asked whether it would have any impact on the value of his property. O'Keefe replied, "Why bless your soul, it would be ruinous." Asked whether it could be used for a different purpose, he replied, "I suppose it might be used for a shoe factory or Salvation Army barracks." Later in the inquiry, he testified that he thought that "the solution of the temperance question was to be found in the consumption of lager beer and light non-intoxicating liquors. If you could see a million people without the colour of liquor upon them it would be a pleasant state of affairs, and that is what I saw in Chicago where Lager Beer is the great

drink." He admitted, however, that he was "not in the brewing business for the sake of temperance."

His testimony was important to the issue. By 1893, he had one of the largest breweries in Toronto in the wake of yet another expansion, producing nearly forty-five thousand barrels of beer annually. A series of illustrated double-page features in the *Globe* in 1895 exposed the interior workings of the brewery to citizens in the wake of yet further expansion. Rather than a single brew house, the O'Keefe brewery featured two of identical size capable of two 3,500-gallon brews daily or approximately five hundred barrels of beer daily. The stock cellars were expanded to include a second location—an entire block of Dalhousie Street, which also housed stables. The main facility was cooled by a fifty-ton De La Vergne refrigeration machine, which was "only permitted to run at their minimum speed. If they were run to their full capacity the whole block would be frozen solid." The article concludes with the open invitation to the public to tour the brewery and see how its ale and lager are made. It was a policy of real transparency and comparatively unusual at the time.

By 1911, the entire structure had been replaced by a new facility capable of producing 500,000 barrels per year or, to put it in perspective, approximately thirty-five gallons for every citizen of Toronto. The same year, he began to withdraw from the brewing business on the occasion of the untimely death of his son, Eugene Bailey O'Keefe. A slowdown on O'Keefe's part was inevitable. He was over eighty. He remained to the end of his brewing career a proponent of temperance rather than prohibition and was quoted as saying in 1912, "The prohibition of the bar is a preposterous and infamous policy. You can't make men sober by act of Parliament." History would prove him correct.

O'Keefe would use the wealth that he had generated from his involvement with the brewery and the Home Bank to improve the society around him. He would not only build churches to serve the community but also purchase and donate existing churches to new immigrant communities in the city. He had significant influence with the St. Vincent de Paul Society and helped establish Toronto's first low-income housing. For his consistent dedication to the betterment of society, he was made a Papal Chamberlain in 1909.

O'Keefe's death in 1913 was marked by a funeral procession of the cadets from De La Salle College and two hundred brewery employees. Three thousand people made up the congregation at his Requiem at St. Michael's Cathedral. Pope Pius X had sent him a blessing on his deathbed. Archbishop McNeil summed up the spirit of Eugene O'Keefe's attitude thusly:

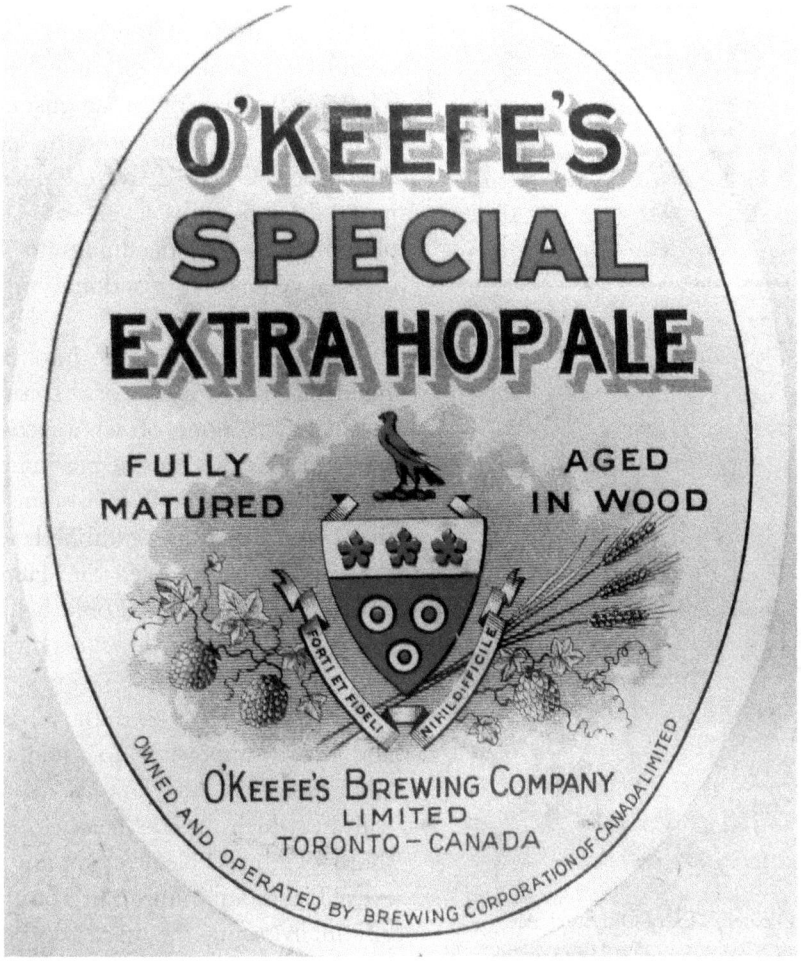

O'Keefe's Special Extra Hop Ale was released after prohibition. The Latin motto translates to "To the brave and faithful, nothing is impossible." By this time, the brewery had already been purchased by E.P. Taylor, rendering that motto slightly less relevant. *Molson Archive.*

> There was a good deal of benevolence practised in the world today, but in what spirit was it done? Was there not a sharp dividing line between those things that were done for men alone and those who had God in view? He need not ask on what side their dead friend was placed. He commended the example of the departed man to other well-to-do men and said that if wealthy men would remember they had a social as well as an individual function, the labour problems of the world would soon be solved.

Top: O'Keefe's Extra Old Stock Ale purports to contain more than 2.5 percent proof spirits. That would be slightly less than 1.5 percent alcohol by volume. It's easy to see why breweries suffered in the wake of prohibition. *Molson Archive.*

Bottom: O'Keefe's Old York Ale preys on the feeling of nostalgia generated for ales in a post-prohibition period, where lager was already becoming king. People fudged dates in marketing even in the 1930s. The O'Keefe Brewery wasn't established until 1863. *Molson Archive.*

His greatest philanthropic act would be completed posthumously. The construction of St. Augustine's Seminary in Scarborough cost $500,000. O'Keefe was typically modest about it even in the planning stages, declining to be interviewed about his donation or the construction.

The brewery passed into the hands of a group of Toronto businessmen, none of whom could match O'Keefe's business acumen. In comparison to O'Keefe, some of the behaviour they exhibited was downright inadvisable. Sir Henry Mill Pellatt built Casa Loma, which proved to be incredibly expensive to build (totalling seven times the amount O'Keefe's seminary cost) and nearly impossible to maintain. Charles Millar was famous for his will in which he bequeathed one share of the O'Keefe company to every Protestant minister in Toronto, essentially using the hard work of a man who had struggled to better society to make a perverse point about human nature.

The O'Keefe Brewery, because of the sheer volume that it produced, was one of the cornerstones of E.P. Taylor's Canadian Breweries. The brewery had survived prohibition by making various flavours of soda. While it was not one of the initial purchases made in 1930, the production volume allowed Taylor to streamline his empire, shutting

down redundant breweries around the province. By the 1960s, the production had increased to 750,000 barrels. Production was eventually transferred to a new facility near Pearson Airport, which is still in operation under Molson Coors. The O'Keefe Brewery was demolished and the land sold to Ryerson University. O'Keefe's house still stands one block east of Victoria and Gould and has been converted to student housing.

Chapter 15

TORONTO BREWING AND MALTING COMPANY, 1859–1967

The William Street Brewery is difficult to picture because both the brewery and the street it was named after no longer exist. While the location of the brewery never changed (breweries don't just get up and walk away), the street names in the area changed with alarming regularity. Before 1860, Simcoe Street above Queen was called William Street. The brewery was on the block at the northwest corner of William and Anderson. Eventually, William Street became Simcoe Street, and Anderson was folded into Dundas Street. In point of fact, the William Street Brewery was so large that it causes the short jogs on Dundas Street in either direction.

It's not surprising that it was built to a high standard. It was the product of profound dissatisfaction with an older brewery. John Armstrong Aldwell and his brother, Thomas, had become the proprietors of the Victoria Brewery at the corner of Victoria and Gould at some point in the early 1850s. While other brewers would own it eventually, the problems that the Aldwell brothers experienced with it suggest that the original brewers, Charles Hannath and George Hart, were right to sell out when they did. In the 1850s, the city infrastructure north of Queen Street was not up to much. There might not have been running water, and sewers were certainly not widely available. When you consider that Victoria and Gould is just a block from the main thoroughfare of Yonge Street, it becomes obvious that growth had outstripped public infrastructure.

John Aldwell was an ambitious man, and it's likely that he was attempting to produce just as much beer as was possible out of the Victoria Brewery.

Large production in a brewery means that there will be an even larger amount of waste liquid produced. In this case, there was no adequate drainage for the facility, and the wastewater simply flowed into the ravine on the next property over. The difficulty was that everyone in the neighbourhood was using that ravine for their drainage. It was a risk to the public health and a real eyesore.

Called in front of the court to settle the matter, it became clear that there was no plan for improvements in the neighbourhood. The box drain that Aldwell had installed to solve the problem had been removed by the board of health, which insisted that he pay double the going rate for the privilege of using the city's sewers. The brewery's business was being held hostage by poor infrastructure. Aldwell would either have to pay an exorbitant amount for the use of the city sewers or continue to pay increasingly large fines. Either way, it must have been frustration enough for him to decide to offload the property in 1859.

The solution to the problem was comparatively brilliant. In 1859, there were not state-of-the-art brewing facilities in Toronto. The majority of the operations that existed had been hand built by first generation settlers, and while they were of a size, they made do with brewing techniques and technology that existed in the 1820s. While the initial buildings were being constructed on William Street, Aldwell toured England to view the large industrial breweries that began to fill the landscape of the Victorian period. According to the *Globe* on July 29, 1859: "It is to be erected a little west of the College Avenue, facing William Street, and will be three storeys in height, 118 feet long by 93 feet broad, with a cellar 15 feet deep. The front will be of white brick, the remainder of the building red...steam elevators will be erected, and that provision for brewing from eighty to one hundred thousand gallons of ale and porter per month will be made. Probable cost $36,000."

The brewery would have been massive. At maximum capacity, it would be able to produce the equivalent of just under a barrel of ale for every citizen of Toronto. It's unsurprising that flooding the market in this way caused some controversy.

Temperance advocates had begun to take notice of the expansion of the brewing and distilling industries in Toronto. J.J.E. Linton made note of the expanded trade in the supporting notes to his proposed bill to Malcolm Cameron, MPP, in 1860. He quotes first the *Globe* from the year the brewery was completed as saying, "A very extensive brewery has been erected during the year by Mr. Aldwell...which will be one of the

The Toronto Brewing and Malting Company, constructed by John Aldwell, was certainly the most attractive of Toronto's Victorian breweries. The sense of symmetry and attention to design is immediately apparent. It kept the bear out back. *From* Timperlake's *Illustrated Toronto.*

most complete establishments of the kind in the province. He has spared no money in introducing all the latest improvements, and his enterprise entitles him to success."

Linton's take on the matter differed substantially from the paper of record: "We ask this question: What good morally, religiously and socially, to Toronto, does the above 'Liquor Manufacture,' in its city, accomplish?"

Two decades earlier, some of the most accomplished proponents of temperance in Toronto had been brewers. They had understood that it was possible to divert the proceeds of vice to assist in the betterment of their society—that there could be harmony. It was, perhaps, a sign of the changing times in a city whose population was expanding rapidly that Linton could not see the potential value of the industry. The early settlers had been able to exert their will on an untamed landscape and create a society. Creation and maintenance require different approaches.

Aldwell might have fit more easily into the previous generation of settlers, according to his son Thomas Theobald Aldwell's memoirs: "My father had started making beer in a tub and when he died he had what at that time was the largest brewing and malting company in Canada. It comprised half a block on Simcoe Street. As I recall there were four stories in this concrete building. Father never took a drink. He would put the beer in his mouth to get the taste and then spit it out without swallowing any of it."

This label for the Toronto Brewing and Malting Company's XX Porter illustrates both the reach of the brewery, having been bottled in Montreal, and the system of gradation used ales and porters in the Victorian period. The additional X means it's a stronger beverage. *Molson Archive.*

While he may not have swallowed any beer, he certainly made more of it than anyone else in Toronto—nearly twice as much as the next leading brewery. That was not the limit of the plan for Aldwell's William Street Brewery. The brewery was renovated in 1863. In 1866, it was vastly expanded. The main building was raised two and half storeys, which would likely have made it the tallest building north of Queen Street. An elevator was installed for moving grain through the building. The wort cooler could manage fifty barrels per hour. The malt kilns and the offices were all gas lit. It was a thoroughly modern concern covering an acre of ground.

In 1868, it became the second-largest malt house in North America. While the stock quotes in the *Globe* for the time reference breweries dealing in bushels of malt purchased at market, it refers to Aldwell's purchases for his brewery by railcar. The gargantuan malt house was described in the newspaper thusly:

> *The frontage of this new addition, on William Street, is 125 feet and the frontage on Anderson Street nearly 86 feet. The height from the ground to the top of the roof is about 60 feet, divided into six stories with an underground cellar way under about one half of the structure. At each corner of the new building are towers projecting up to a height of about 10 feet further, and capped with handsomely finished gilt vanes. In the architectural design, the modern French style predominates, and has been made to combine beauty with utility, as closely as they can be allied with permanency and strength… In every sense, the building is of the most substantial character, the supports on the different floors being of iron, while the steep roofs are slated.*

Aldwell had significantly expanded his business, and he had done it with style. Not only that, but he had also worked in impressive technical detail.

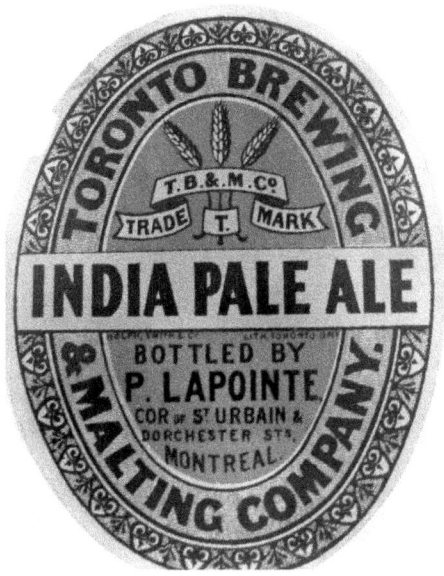

This label from the Toronto Brewing and Malting Company suggests that there may have been a playing card motif in the 1890s rebrand. Note the spades running along the border of this ovular label. *Molson Archive.*

Rather than direct-fired kilns, the malting system had furnaces in the basement with chimneys used to direct heat to kilns on different floors of the building. Between the old and new buildings, Aldwell's brewery had the capacity to malt 220,000 bushels per year. So massive was the enterprise that they constructed two grain elevators on the wharves downtown for incoming barley and outgoing malt. He was known to charter entire ships to sell his product in Chicago. His brewery remanded one-tenth of all the duty paid by the hundred plus breweries in Ontario.

It's unsurprising that Aldwell and his brewer, William Scott, were chosen as the scientific experts on new agricultural products. In later life, when George Brown had taken up farming at Bow Park, he experimented with a strain of barley called Chevallier, which he likely acquired during one of his trips to England. In Upper Canada, the majority of the barley in use was six-row, which is slightly higher in protein and slightly lower in starch. In December 1869, the two varieties were malted side by side. The Chevallier took slightly longer to germinate but resulted in improved yield and greater extract when compared to the varieties in current use. Had circumstances been slightly different, Ontario might well have switched to two-row barley in the 1870s.

Aldwell's ambitions didn't stop with the malt house. He had a plan to open a sugar refinery in addition to it. The minutes of city council's discussion of the proposal reveal the staggering scale of the project. He had asked for twenty-five years' worth of local tax exemption for a refinery that would require an outlay of $175,000 and employ 175 men—slightly more than 1 percent of the working population of the city at the time. It would have been the largest operation of its kind in Canada.

Lost Breweries of Toronto

Not only did the Toronto Brewing and Malting Company have the second-largest malt house in North America (pictured in the foreground of its stationery), but its sales reach had also extended into Northern Ontario by 1876, giving it one of the country's largest distribution networks. *Thomas Fisher Rare Book Library.*

Unfortunately, Aldwell died at forty-seven in Ogdensburg, New York. It's likely that he was returning from England or negotiating sales of his malt at the time, Ogdensburg being a prime rail connection. It was an unfortunate time for his passing, as the brewery's ownership was in the middle of being restructured. Brooks Wright Gossage had been a partner in the business and had decided to part ways with the company. Thomas Aldwell, John's brother, took the opportunity to get out of the business upon John's death. Louisa Aldwell was left attempting to run one of the largest breweries in Ontario without any financial expertise or firsthand knowledge of the industry.

John Aldwell may have been a visionary, but without a plan in place for the eventuality of his death, the business would pass into the hands of others who lacked his ambition and entrepreneurial drive. The next year, the brewery was restructured as the Toronto Brewing and Malting Company. It would go through several changes of management, all of them somewhat less inclined to the task of running the brewery than its founder. While the day-to-day running of the business would remain in the hands of the brewers and maltsters, the management was fraught with petulant intrigue.

In 1881, J.N. Blake, the president of the company and primary shareholder, went on vacation to England. During his absence, the members of the board of directors made a number of shocking decisions. For one thing, they donated the brewery's mascot, a black bear named Bruin, to the newly opened zoological gardens. For another, they decided to usurp Blake's role as president of the company. The annual meeting was delayed without notice, causing Blake to miss it. The board, led by H.L. Hime, voted Hime in as president of the company.

Under Hime, the board's position was that since the majority of the stock owned by Blake was held by banks as collateral for advances on the Toronto Brewing and Malting Company, he did not really own the stock. He merely represented it. Blake's position was that since the annual meeting had been delayed, the decision to replace him was made at a special meeting and that the whole issue was highly irregular. The matter was eventually brought to the courts when Blake entered the brewery with ten specially deputized bailiffs and seized control of the management offices, bolting the doors. The act of locking the maltsters and brewers out of the offices was as literal as it was symbolic.

The presiding judge on the case refused to find in favour of any of the parties involved, suggesting that it was not a matter for the courts. The upshot of the dispute was that several of the board members and many of the employees of the Toronto Brewing and Malting Company left in order to take over Copland's East Toronto Brewery. The management of the company had not merely failed to grow the business but had actually created additional competition.

There is some evidence that the lack of a clear direction for the company persisted throughout the 1890s. The president of the company, Alexander Manning, was more interested in political life and his other business ventures. In 1885, Manning campaigned for a return to the mayoral office on his record as "the best mayor Toronto had ever had" but was ultimately defeated by William Howland because of Manning's involvement with the brewery. In fact, a petition for a reduction in the number of licenses available within the city of Toronto was brought before him in December 1885. The results were entirely predictable considering the mayor's business

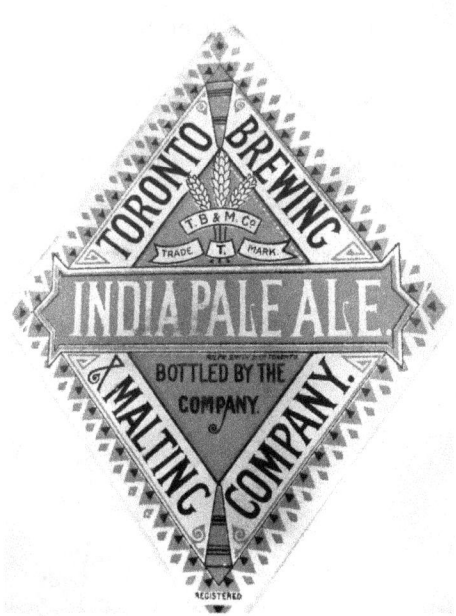

The diamond-shaped label of the Toronto Brewing and Malting Company came about through the launch of an individual brand called Diamond Ale in the late 1890s. While Diamond Ale did not survive as a brand, it changed the branding for the rest of the beers on offer. *Molson Archive.*

interests. The brewmaster would have been John S.G. Cornnell, who had closed both the Farr and Spadina breweries; Cornnell haunted Toronto's late Victorian breweries like the grim spectre of death.

There is also a prescient example of marketing being as important to the brewery as the product. While they brewed stout, amber and India pale ales, they also briefly offered a Diamond Ale. It was quickly abandoned, but the labels employed for all of the brands took on a diamante shape as a recognizable trademark. At the turn of the century, all three of those beers would have routinely been between 6.5 percent and 7.0 percent alcohol. The low final gravity on all of the products would have rendered them very dry, although the stout would have been the sweetest.

There is little to report of the brewery through the first decades of the twentieth century. It carried on through Manning's death and in spite of Cornnell's track record. It was purchased and managed by the Cosgrave Brewery before prohibition, marking a brief period of stability. By the time of prohibition, it had become a vinegar factory. It was only in 1927 that it began to produce beer again. It had begun to produce a lager brand known as Liberty Beer, which failed to capture the imagination of the public. The rebrand of that beer to Canada Bud was a knowing emulation of the

When you look at the label that Canada Bud was using for its beer, you realize very quickly that Anheuser-Busch ought to have sued the brewery sooner, if anything. The owners must have been completely bereft of ideas. *Molson Archive.*

branding of Anheuser-Busch's Budweiser brand. It proved so successful that it renamed the brewery in 1928 to Canada Bud from the Toronto Brewing and Malting Company.

The company was sued almost immediately, and rightly so. By 1933, the lawsuit with Anheuser-Busch had forced a label change, causing the brewery to lose its most potent marketing weapon: duplicity. It would almost certainly have paid a larger settlement if prohibition in the United States had not prevented Anheuser-Busch from competing in the Canadian market for the previous decade. As it stood, it was forced to pay the princely sum of five dollars in damages.

The management of the Canada Bud brewery was extremely slippery. While it was profiting from the production of Canada Bud lager, it had reached the production capacity of the brewery. The manager, Charles Kiewel, was of the opinion that rather than expanding the existing facility, it would be more profitable to take over the City Club Brewery. The City Club Brewery occupied the space that had been Kormann's on Richmond Street at Sherbourne. The president of Canada Bud, Duncan McLaren, set about acquiring the brewery for Canada Bud.

A significant problem with the merger of Canada Bud and City Club Breweries was that they produced beer for each other under the other's label. Student Prince Lager is seemingly a tribute to Sigmund Romberg's operetta of the same name, thus catching the lucrative beer-and-opera market. *Molson Archive.*

Left: Canada Bud's Special Bitter Ale was brewed and bottled for it by its subsidiary, City Club Breweries. One wonders how much difference there would have been between City Club's Bristol Ale and this product. I suspect the label may have been the sole difference. *Molson Archive.*

Right: Canada Bud Stout was produced at the City Club Brewery, which had housed Ignatius Kormann's lager business. Why one would produce ale in a brewery purpose built for lager is a mystery. Post-prohibition brewers were mostly interested in getting volume out the door. *Molson Archive.*

The business practices involved were highly irregular. McLaren and Kiewel set about purchasing the brewery themselves, neglecting to use company money or to acquire the approval of Canada Bud's shareholders. McLaren was attempting to sell the newly acquired City Club brewery to Canada Bud for $325,000. From the perspective of the shareholders, the difficulty was that McLaren stood to personally profit $167,335 on the transaction. After protracted meetings with angered shareholders and allegations of fraud in the courts, McLaren and Kiewel decided to transfer the property to Canada Bud at cost.

The difficulty was that by 1933, with twice the production that it had previously had access to, the brewery had lost its marketing gimmick. The Kormann facility, designed to produce lager, was producing stout and bitter. The Toronto Brewing and Malting facility, designed to produce ale, was producing lager. The management not only was untrustworthy but also

had been shown to be actively working against the interest of the company. Canada Bud lasted about four years before being purchased by E.P. Taylor's Canadian Breweries Limited. In 1944, Canada Bud was rebranded under the O'Keefe name, and the City Club brewery was closed.

Aldwell's William Street Brewery stood for one hundred years at the northwest corner of Dundas and Simcoe before its closure in 1967. It was the only legacy of one of Toronto's most determined entrepreneurs. Had John Aldwell lived beyond forty-seven, it is likely that the face of the brewing industry in Canada would be very different today. Sadly, the potential that he created was frittered away over decades by incompetent, disinterested or unscrupulous management. Of all of Toronto's early brewers, Aldwell's memory deserves better.

Chapter 16

THOMAS DAVIES AND THE DON BREWERY, 1846–1907

The Davies family emigrated from Ashton Upon Mersey, Cheshire, in about 1832. They were not initially brewers, but rather farmers. They settled three miles to the north of the town of York in the third Concession. Initially, the location where they settled did not have a name and acquired one only when John Davies became the area's first postmaster in 1840. (Throughout the official records of the time, the name is given as both Davies and Davis.) Davisville was never as populous a village as Yorkville or Eglinton and consisted of only a few hundred people.

The three Davies brothers—John, Thomas and Nathaniel—had a farm on the east side of Yonge Street that stretched east as far as John and William Lea's land. Rather than growing significant quantities of grain, the brothers specialized in breeding livestock. It was not until 1846 that Thomas and Nathaniel Davies opened their brewery on Yonge Street near what is now Balliol and named it, creatively, the Yonge Street Brewery. Very shortly after its founding, they added the Yonge Street Brewery Hotel.

The Yonge Street Brewery would have done a comparatively small trade, and it's probably for this reason that Thomas and Nathaniel Davies dissolved their partnership in 1849. In 1853, Nathaniel sold off the majority of the livestock that had lived on the farm in order to focus his complete attention on brewing. The Davies farm was a popular spot for agricultural contests. The York Township Agricultural Society's annual plowing match was held there in 1860. As a brewer, it was a brilliant method of letting potential customers work up a thirst. Nathaniel Davies would continue to run the

Yonge Street Brewery until 1862, at which point the property was sold. At that time, it was capable of producing one hundred barrels per week, although it likely did not have the ability to produce ale year round.

Thomas Davies would focus his attention on a brewery that he was able to purchase at the intersection of Queen and River Streets, popularly known as the Don Bridge Brewery. It had been built by William and Robert Parks in 1844 but was more ably administered by Davies, who had five separate pubs distributed through downtown Toronto acting as his agents within months of taking over in 1849.

The brewery continued in the thoroughly unremarkable way that some breweries do. It sat on the banks of the Don River and continued to produce ale through the 1850s and 1860s. Thomas Davies was engrossed in the creation of housing on lots that he had improved, and the brewery, while profitable, was more of a means to create additional wealth than anything else. It was not until Davies enlisted his eldest son, Thomas Jr., in 1868 and changed the name of the firm to Thomas Davies & Son that change began to take place. The bill of fare at the time consisted of cream ale, pale ale and Porter. Cream ale was something a novelty in Toronto at the time and would have been aimed at competing with the influx of lagers newly available from the United States. The capacity of the brewery was two thousand gallons per day, or about twenty-eight thousand barrels annually.

This version of Davies Cream Ale was likely a product of the first decade of the twentieth century. The inclusion of the maple leaf on the design tends to suggest that the cream ale is more representative of Canada than the Blue Ribbon Beer from the same period. *Molson Archive.*

LOST BREWERIES OF TORONTO

This image of the T. Davies and Bros. brewery captures a moment in history from the year before Robert T. Davies left to open the Dominion Brewery. By 1881, Thomas Davies was hard at work replacing this facility with a much larger one. The basic structure here dated from 1848. *From* Timperlake's Illustrated Toronto.

Thomas Davies Jr. found himself, at the age of twenty-four, in charge of a brewery of not inconsiderable size. His uncle, Nathaniel, had passed away in 1866, and his father, Thomas Sr., passed away very shortly after making him a partner in the firm. The farm at Davisville had long since been sold off. It must have been a difficult transition, as having no choice in your livelihood but to operate a brewery might be daunting for a young man. There's not a great deal to suggest that Thomas Davies was much of a brewer, even though he was highly educated. The relative inexperience showed through in the fact that the brewery was very nearly seized for excise discrepancies in 1871.

Fortunately, Thomas was not completely alone. His brother Joseph would become the managing director of the brewery and stay in that position indefinitely. By 1872, they were able to bring their younger brother, Robert, twenty-three years old at the time, into the fold and change the name of the brewery to Thomas Davies & Bro. Robert would have added a great deal of energy and focus to the arrangement.

By 1873, Thomas Davies found himself with enough free time to consider the widespread request that he run as a candidate for alderman in St. David's Ward. He had finally found in political life an arena in which he excelled. In his first year as an alderman, he successfully led a movement to acquire John George Howard's High Park for the city of Toronto, creating a large green space that exists to this day. It's not without some irony that it

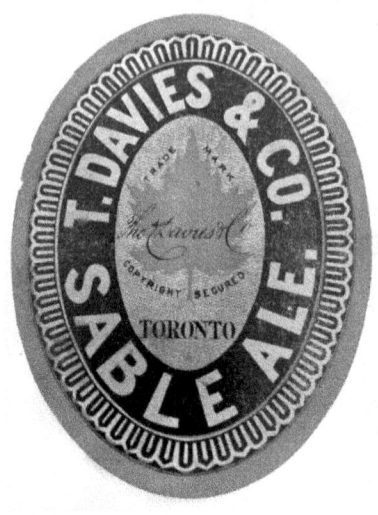

This early label from Thomas Davies's brewery illustrates the development of branding in Toronto brewing. While it is almost certainly a stout or porter, Sable Ale is a far more persuasive name for those who are picking amongst a number of products. *Molson Archive.*

is one of the few places in Toronto that remains free from sales of alcohol, in accordance with Howard's wishes.

Davies was also instrumental in three other important pieces of business, none of which can be said to be entirely selfless for a brewer. He led the way in securing Riverdale Park for the city, a move that greatly benefited the citizens and at the same time managed to ensure that no breweries could be opened up on a large section of the Don River. In 1877, just before his temporary retirement from the position as alderman, Davies advocated as a member of the board of works for the takeover of the Furness Waterworks by the City of Toronto. This was generally beneficial to the city, as Furness's infrastructure had proved inadequate on any number of occasions when buildings caught fire or even in simple day-to-day use.

The waterworks were improved significantly. If you were a brewer, and you had foreknowledge of such a takeover by the city, you would be able to plan for it. The description of the new lager beer plant built by Davies & Bro. in 1877 reads as follows:

> Great ingenuity has been displayed by the Messrs. Davies in fitting up and arranging the various departments that more business is done in proportion to the number of hands employed than in any other establishment of the kind in the Dominion. By using the city waterworks the water is forced to the highest level in the brewery, and thus they are enabled to do away with the time honoured pump. This is the first, or one of the first, breweries in Canada fitted up without a pump, and the arrangement of the tubs has been found to be so perfect that other brewers adopted the same style.

Davies & Bro. was one of the early adopters of lager brewing in Toronto, beating O'Keefe and Cosgrave by just under two years. The 1877 plant expansion came with the construction of Thomas Davies home at the

northeast corner of Queen and River Streets. Called Rivervilla, it was a massive structure of a fanciful Italianate design. It would not be the last expansion for the brewery. An expansion of the original malt house and ale brewery structure increased brewing volume from 2,000 to 7,500 gallons per day. The malt house was capable of producing 250,000 bushels of malt per year.

It was not coincidence that Davies emerged from retirement as an alderman in 1881 and led a project to straighten, widen and deepen the Don River. The straightening of the river provide increased navigability for small steamboats, and the embankment that had run next to the Davies brewery was widened enough to create a rail line on it. For a brewery that had nearly quadrupled its capacity, this was a well-timed development.

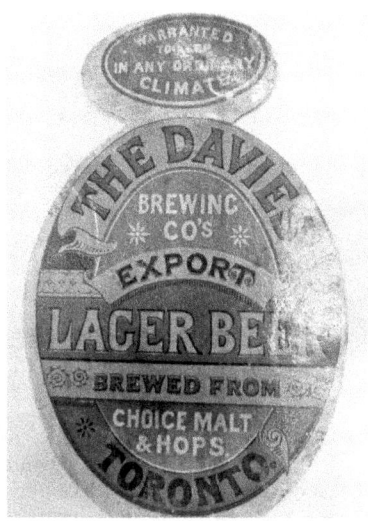

This label for an export lager beer comes from the period during which the Davies Brewing and Malting Company was owned by a British consortium. Where exactly it was being exported to is a mystery, but it was warranted to keep in normal climates. *Molson Archive.*

In 1878, when Robert Davies left to found the Dominion Brewery just down the street, the brewery was renamed T. Davies & Company. In 1883, it became a joint stock company, and the name changed once again to the Davies Brewing and Malting Company. The prime difficulty in this era was the fact that there was very little consistent branding to be found amongst Davies's products. By 1885, it had the sole use of the Blue Ribbon trademark in Canada but little in the way of promotion for it in periodicals of the day. It had replaced the promotion of its Pioneer Lager. The Gilt Edged Pale Ale was a longer lasting brand, making it all the way to the 1900. The cream ale may have been the longest lasting of all judging both by advertising mentions and current availability of labels to collectors. It also made a range of odd products in the 1880s like quinine ale and Porter, odd for a brewery that tended to focus on lighter-strength beers.

There was also some question as to the ongoing quality of the product. In the magazine *Grip* in 1885, this paragraph appears in a pro-temperance article:

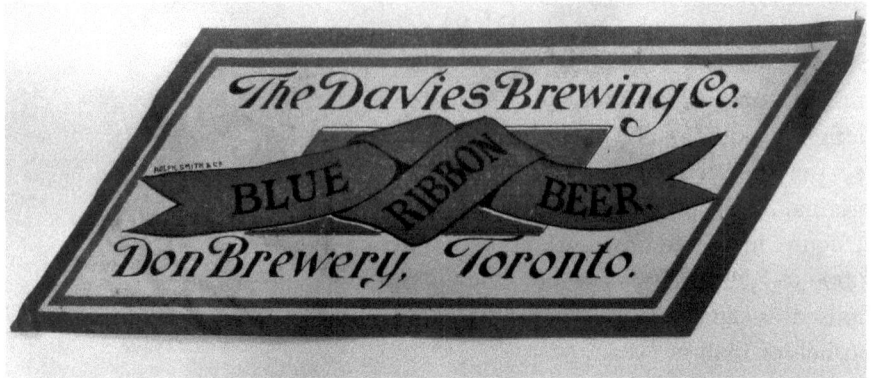

The Davies Brewing Company was clearly connoting the production of a lager with a reference to the Pabst Brewing Company from Milwaukee. This simple label is likely from the first decade of the twentieth century, a vast decluttering of earlier designs. *Molson Archive.*

> *I see that Mr. Davies says the Blue Ribbon Beer that Cooper and Beckett—silly fellows—got drunk on, was brewed last June, was thick, muddy, etc., and not fit to drink. How was it, may I ask, that such stuff was on sale? Is that the way Mr. Davies serves his customers who bring him good money? And what has its bad quality in other respects to do with its alcoholic percentage? Mr. Davies says he can brew a beer entirely free from alcohol. Why, then, does he not do it and make a fortune?*

One feels the goalposts shifting very slightly towards the end of the article, but the point is well made. As we have learned in a contemporary understanding in beer sales in Ontario, a product that frequently changes its packaging is not always to be trusted. Additionally, despite the heartfelt wishes of the temperance movement, it's hard to make friends with de-alcoholized beer.

Thomas Davies's involvement with the Don Brewery would continue until 1894. In 1891, a consortium of British investors would buy out his brewery, the Ontario Brewing and Malting Company and the Grant Spring Brewery in Hamilton. All told, the investment would be backed by $2,750,000. It was likely too high a price to pay, and in the long term, the properties were almost certain to depreciate without talented managers or the drive to expand.

The last hurrah for the Davies Brewery came in 1903. In 1902, there had been protracted discussions in the newspapers about the potential of using the building as an additional pork packing plant, but that was shouted down by citizens who did not want another such building in their backyards.

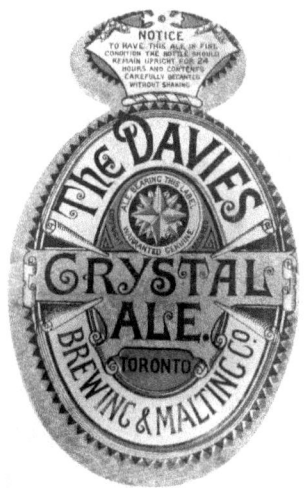

Left: This overelaborate label and compass rose is from the brief period in the 1890s when the Davies Brewing and Malting Company was owned by a British consortium. The label is topped by a crown and comes with a set of instructions for pouring. *Molson Archive.*

Below: Another view of the T. Davies and Bros. brewery from 1877. Prior to the straightening of the Don River, it ran right next to the cooperage (foreground right) and stables (foreground left). Of the two large breweries, the one on the right was the ale brewery and malt house. *From* Timperlake's Illustrated Toronto.

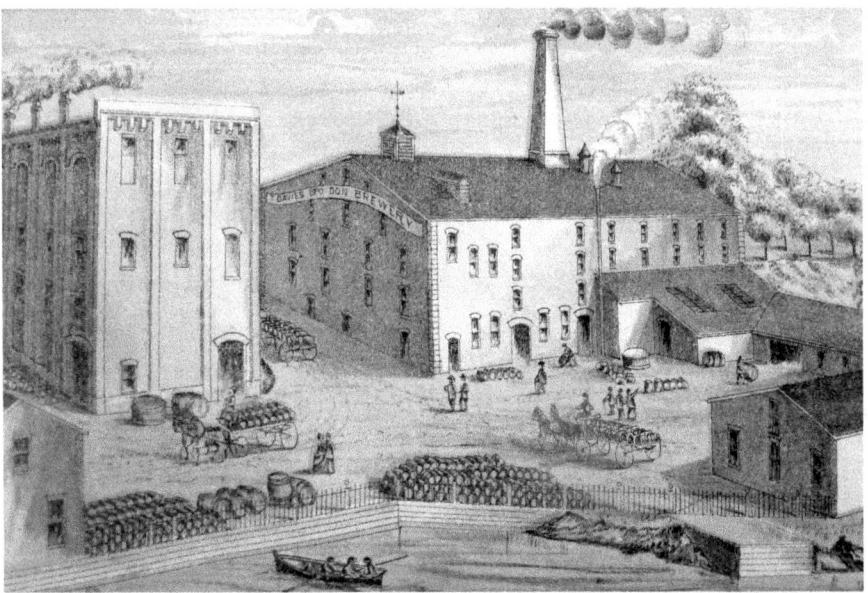

City officials were quick to point out that the nearest dwelling was well over five hundred feet away, although their assurances proved futile. The English consortium that had purchased the Davies Brewery in 1891 had been attempting to unload the property for some time but had only been able to manage a bid of $15,000 at open auction—a figure that constituted less than half of the reserve bid. Fortunately, a man named John Dick purchased the brewery in 1903, retaining the Davies name.

LOST BREWERIES OF TORONTO

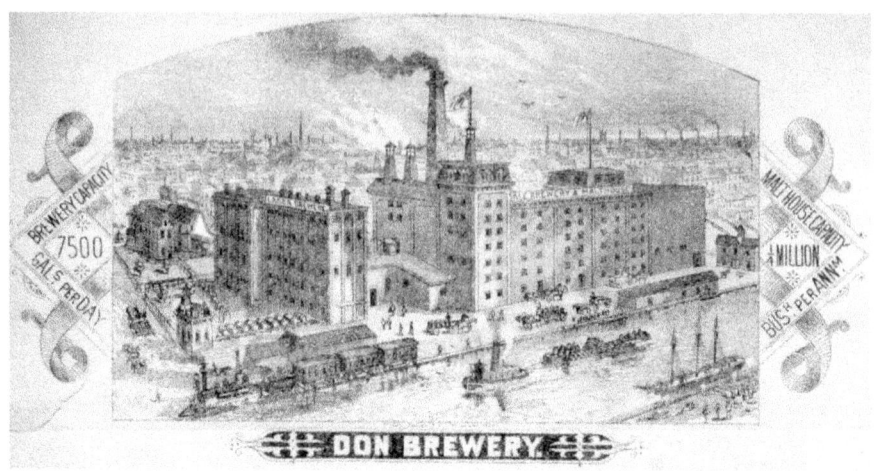

The Don Brewery, seen here on the company's stationery, went through a prodigious expansion under the ownership of Thomas Davies Jr. It was certainly vast. This view is looking west at the brewery from across the Don River. The building on the left, labeled "Lager Brewery," still stands today as condominiums. *Thomas Fisher Rare Book Library.*

The Davies Brewery's lager beer facility is the last surviving piece of that establishment. It has been turned into a quite attractive set of condominiums called the Malt House, but the building was never used for that purpose. *Winston Neutel.*

The Davies Brewery became the first in Toronto to unionize, joining the United Brewery Workers. For a period of nearly six weeks in 1904, the Davies Brewery was the only one operating at full capacity. That year, nearly seven hundred brewery workers in Toronto had walked off their jobs after demanding a 25 percent pay increase to $13.50 a week and a reduction from sixty-hour weeks. The brewery workers were so serious about the issue that they briefly allied with the temperance movement, threatening the very existence of their employers' businesses.

The Davies Brewery was destroyed by a fire in 1907. The cause of the fire was given as spontaneous combustion. John Dick had insured the property for its entire value but was using a large portion of the outbuildings for another concern, the Ontario Storage Company. With no particular expertise in brewing or interest in reconstructing the plant, the Davies Brewery was officially shuttered in 1910. The southern building, which had housed the manufacture of lager, stands to this day as condominiums erroneously named the Malt House.

Thomas Davies passed away in 1916 just months after his brother Robert Davies. Just three years earlier, he had run for mayor against H.C. Hocken. Had he won that election, Thomas Davies would have been the man to approve the Bloor Viaduct. Although his career as a brewer lasted from 1868 to 1894, he spent the majority of his adult life as a public servant. Unlike his brother Robert, Thomas had used his gifts to help guide the city of Toronto through difficult periods of expansion and accomplish things that were difficult, even unpopular, but ultimately necessary and beneficial for the majority of its citizens. That these actions also assisted his business interests was a happy arrangement of circumstances.

Chapter 17
ROBERT DAVIES AND THE DOMINION BREWERY, 1878–1936

Key to understanding Robert Davies and the Dominion Brewery is the fact that Davies was intensely competitive. It probably resulted from his involvement in horse racing at an early age. In 1865, at sixteen years old, Robert Davies jockeyed a horse called Nora Criena in the Queen's Plate. Due to a bizarre series of disqualifications on the basis of nationality and handicapping in the first and second heats, he actually won the third heat by a length and by all rights should have taken the Queen's Plate. For reasons that are lost to history, the award that year went to the fourth-place finisher. For a competitive young man, coming second would simply not do. As an operating principle, Robert Davies was interested in being the best in the world.

Robert Davies was fuelled by this sense of competition even when it came to the family business. As the younger brother of Thomas Davies, Robert was an integral part of the firm at the Don Brewery under the name of Thomas Davies and Bro. He cannot have enjoyed playing second fiddle to his brother. Thomas was, by the time Robert joined the brewery, very accomplished politically. It was a vastly different sphere than the equestrian circles in which Robert spent his time.

In 1877, Robert Davies struck out on his own. Given all of the potential locations where he could have set up a brewery in Toronto, he chose a site less than two blocks from his elder brother's operation, suggesting even there a friendly rivalry. The Dominion Brewery stands to this day on the north side of Queen Street at the corner of Sumach, largely unaltered from the way it

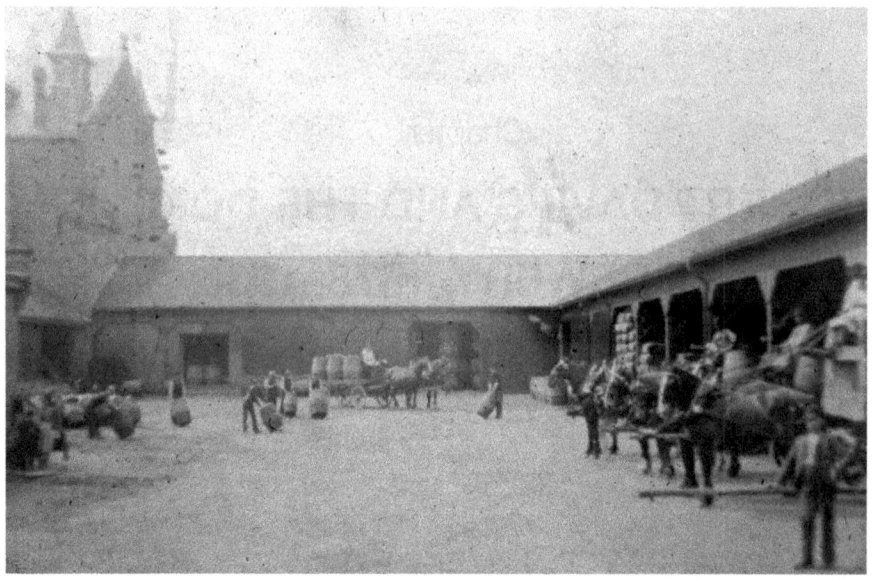

This image of the northern courtyard of the Dominion Brewery raises a good point about how breweries employed so many men in Toronto. In the days before forklifts, manpower would have been the only way to get the barrel on the dray. Hard, thirsty work. *Sean Duranovich.*

was at its advent in 1878. Davies did nothing in half measures. The frontage on Queen Street took up half a city block at three hundred feet, and the handsome mansard roof lent the three-storey building a touch of class and a pleasing symmetry. Davies was completely aware of his own abilities as a brewer. Having come from the family brewery, he was well versed in brewing both ale and Porter, but he must have felt that lager was beyond him. He was not too proud to bring in German specialists for that part of the business. Additionally, the bottling was done at a separate location on Church Street through Davies's agent, Thomas Defries.

The brewery sprung up more or less fully formed, and the 1881 advertisements are different than those of other Toronto breweries of the day. In the majority of cases, the name of the brewery's owner was used simply for the purposes of identification. It might appear once in a print advertisement. Robert Davies's named appeared in the ad no fewer than five times in very large print. He wanted you to know that it was his beer.

The name of the brewery itself was an indication of his intention. The brewery would supply the entire Dominion of Canada. He made this known in the advertisement by running down the list of cities where it is available. This

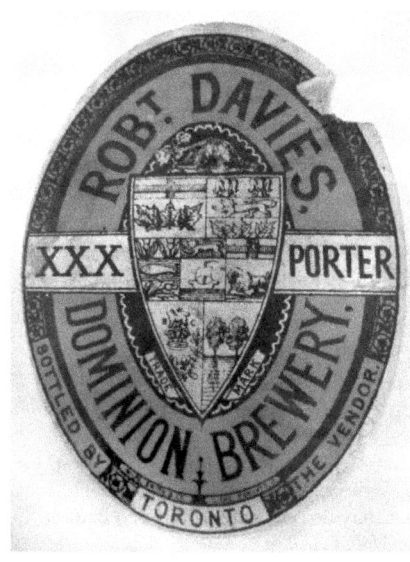

This label for Robert Davies XXX Porter likely hails from before 1885, or else it would boast of its award from the New Orleans Exposition. Many brewers from the time used a beaver in their advertising, but the Dominion Brewery always used it in conjunction with a shield. *Molson Archive.*

was so important to Robert Davies that he updated the same advertisement the next year to add Winnipeg. He had no doubt in the quality of his product. His attitude is summed up in the final sentence: "One trial is all that is necessary to enroll you amongst my numerous customers."

The growth of the brewery was meteoric. Much of the early success that the Dominion Brewery experienced was due to the Scott Act, which passed in 1878 and allowed local option prohibition. It became impossible for Dominion to export full puncheons or hogsheads of beers to towns outside Toronto because it would be immediately obvious to inspectors what the contents might be. Instead, the beer was bottled and then shipped inside unmarked flour barrels at nearly five dozen bottles to the barrel. The Dominion Brewery, because it had adapted its business model to the circumstances that existed at its opening, would continue its rapid expansion.

The brewery excelled in international competition. In 1885, the Dominion Brewery's India pale ale, amber ale and XXX Porter would all be awarded medals at the North Central and South American Exposition in New Orleans. Winning awards for brewing beer was of approximately the same importance in 1885 as it is today—past performance is not an indicator of present quality. Robert Davies did not see it that way. As with the Queen's Plate, which he had finally been awarded as an owner in 1871, Davies viewed the award as sacrosanct—absolute proof that he was the best in the world.

Some men would be content with a small amount of text around the edge of the label on the bottle. Some would choose, as Labatt's had chosen, to simply display the medals tastefully on the label. Robert Davies was satisfied with that for a time. Eventually, he replaced the entirety of the label of his India pale ale with the certificate awarded to the beer in 1885. This was

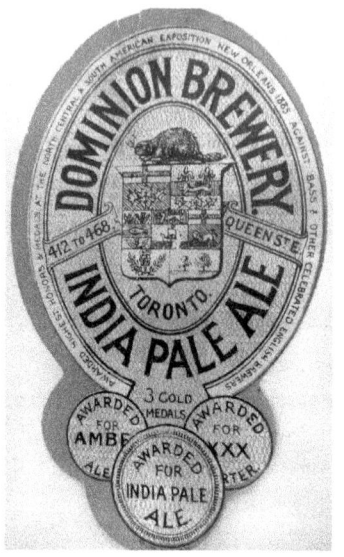

Left: This label for the Dominion Brewery's India pale ale tells us something of Robert Davies's character as a sportsman. Not only is he representing Canada with the beaver and symbols on the shield, but the text around the outside also reminds us that his beer beat Bass and other English brewers in competition in 1885. *Molson Archive*.

Below: The Dominion Brewery's India pale ale was renamed White Label Ale at some point after its triumph in the North Central and South American Exposition in New Orleans in 1885. Rather than simply mentioning the award, as in previous iterations of the label, Davies simply replaced the label with the award in what may be rightfully considered blatant showboating. *Molson Archive*.

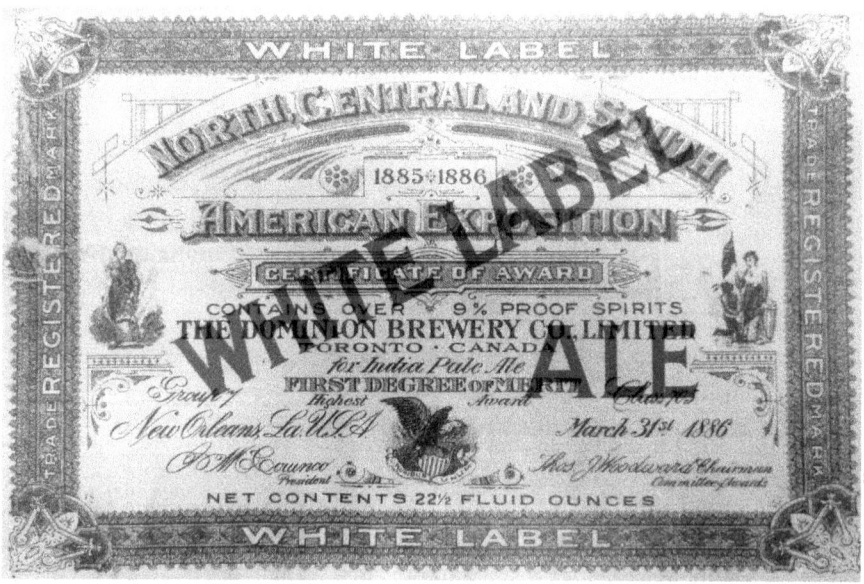

how his White Label Ale was created. Moreover, Davies would subsequently enter his beers in as many competitions as possible. Although it's reasonable to hold some skepticism, there's a real possibility that it might have been as good as the accolades suggest. White Label Ale would have been a 6.5 percent India pale ale made with Kent hops and likely in the style of Bass, although somewhat lighter.

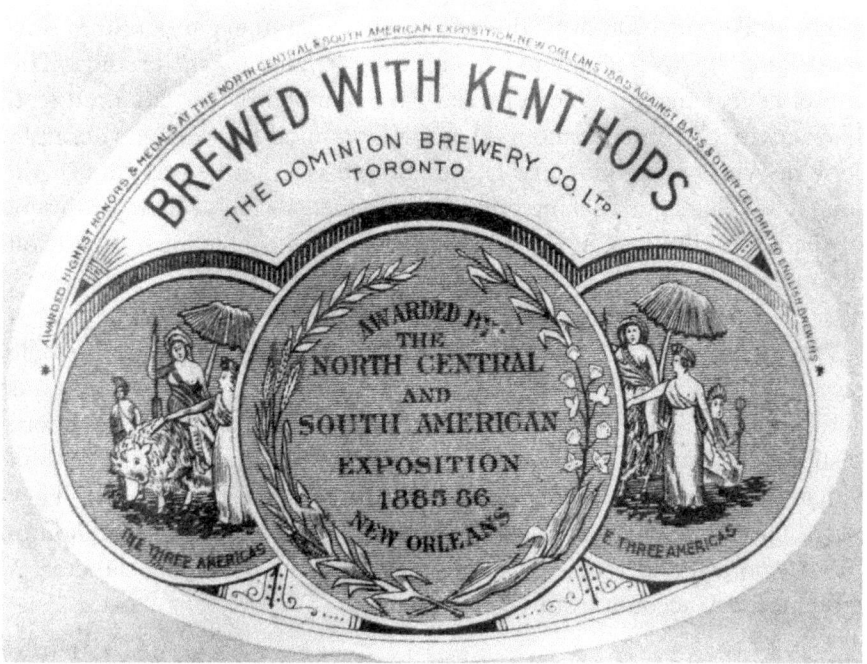

The neck label from the Dominion Brewery's White Label Ale clearly displays that the public would have had enough knowledge of the processes and ingredients in beer to understand that Kent hops were a significant selling point. *Molson Archive.*

Under Davies's energetic management, production at the brewery grew annually. When he had started the brewery in 1878, he was not yet thirty, and he had the ambition of a young man. The year-over-year figures ought to be astonishing to a modern audience. He was adding the equivalent of a small modern craft brewery every year.

TABLE III. DOMINION BREWERY PRODUCTION 1886–1890

Year	Imperial Gallons	Barrels
1886	686,039	26,155
1887	837,674	31,936
1888	1,001,424	38,179
1889	1,078,239	41,108
1890	1,150,162	43,850

The spike in 1888 was the result of a plant expansion that was necessitated by his inability to keep up with demand for the product. The brewery's frontage on Queen Street was expanded by two hundred feet. The activity prompted rumours that the Dominion Brewery was about to be sold. With typical humility, Davies announced that he was "putting in large new cellars and making other improvements which will make this by far the largest brewery in Canada, and which will enable me to supply all customers with Ales unequalled in fine quality in this and other markets." It was to be the largest brewery with the best beer in the world.

Whether or not that was strictly truthful was immaterial, as people certainly believed the reputation. The following year, the brewery was purchased by a British consortium led by Sir Thomas Boord of Boord Distillers in London. English investors were looking for safe bets in Canada, having run out of profitable ventures to invest in at home. They ended up capitalizing the business for $1.2 million (nearly $45 million in today's money) and retained Robert Davies as the managing director. A contemporary account from 1893 explains:

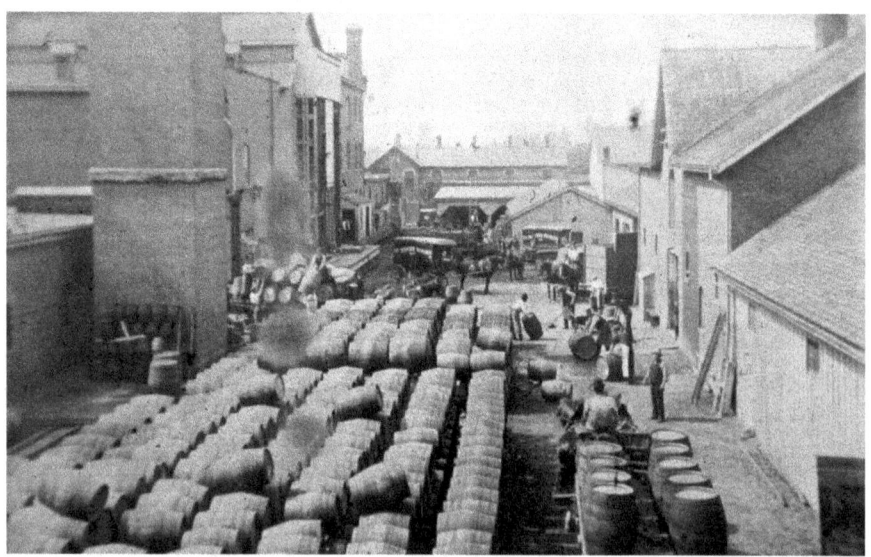

According to the Dominion Brewery's letterhead, barrels were expected to be returned within six months. The scale of the operation is evident here: How many more barrels did Dominion have floating around the city? *Sean Duranovich.*

LOST BREWERIES OF TORONTO

No higher praise could be accorded to Mr. Davies business skill and energy than the flattering encomiums pronounced at the company's meeting in London by the English experts who were sent out to Canada to thoroughly inspect the establishment. Hard-headed men of established business reputations, they pronounced their opinions only after the most rigid personal inspection of every detail, and the result of their exhaustive examination was a plain admission that they had been greatly surprised at finding in Canada such a perfect establishment; in fact their whole report frankly admits that the inspection revealed to them a model brewery that would stand comparison with the best in any land.

The Dominion Brewery represented Canada in 1893 at the Chicago World's Fair. Its display was a twenty-five-foot-tall pyramid that was twenty feet wide at its base. It was constructed in the main of casks and barrels held in place by brass rails and adorned on every surface with pint bottles of different varieties of beer. Awards, certificates and gold medals served as eye-catching highlights. The larger trophies that the brewery had won were showcased in a specially constructed glass case at the rear of the exhibit. Robert Davies had little use for subtlety.

By this time, lager had been phased out of production at the brewery. According to Davies, "It was more troublesome, and I found that we had quite enough business without that." The brands that were still in production were Export Ale, White Label India Pale Ale, Special Pale Ale, Jubilee Pale Ale and **XXX** Porter.

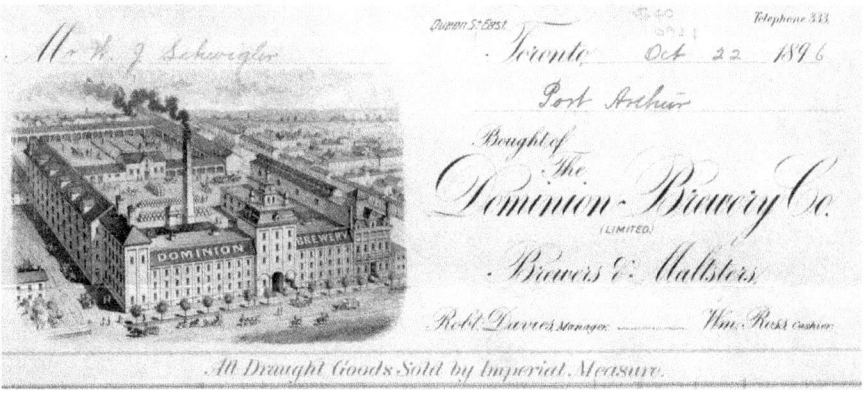

It was the fashion for breweries to have drawings of their facility on their stationery, but in the case of the Dominion Brewery, the size and scale is somewhat exaggerated. While there certainly were stables, they did not stretch all the way to Sumach Street on the right. *Thomas Fisher Rare Book Library.*

In 1894, Davies found himself giving testimony in front of a commission on liquor traffic in Ontario. His answers reveal that even for a supremely confident manager, the concerns that brewers have from day to day have not changed in the last 120 years. The supply chain was a major concern. In a decade, the brewery went through 700,000 bushels of malt. Since the tax in those days was not on beer being sold, they paid approximately $550,000 in malt duty between 1882 and 1892. Another serious concern was making sure that there were enough kegs to ship product. Dominion employed its own cooperage on a back lot that was purchased when the English investors took over in 1890. The total value of the barrels the beer was shipped in came to somewhere between $100,000 and $125,000, or about one-tenth of the capitalization of the brewery. Sales were dependent on external factors. In 1885, sales were noticeably lower because people were drinking whiskey due to a particularly nasty epidemic of grippe.

It has been reported by a number of sources that Robert Davies owned 144 pubs within the city of Toronto. This is apocryphal. For one thing, he only became wealthy enough to do that in 1889, after the English investors capitalized the firm. This was at a time when the number of licenses in the

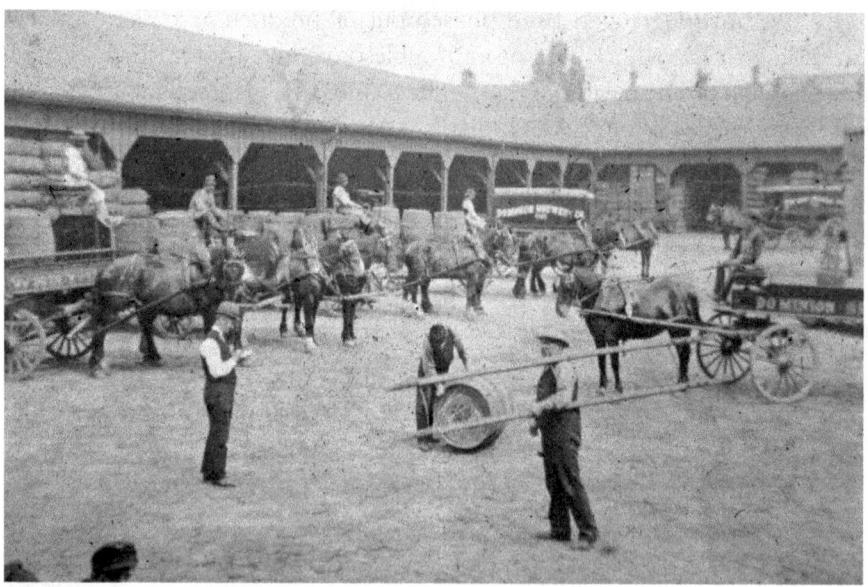

This is the stable yard of the Dominion Brewery, a large courtyard at the northern end of the property. Note the several kinds of wagons employed by the brewery for the purposes of delivery. The brewer's drays seem to have specialized in transporting barrels, with special closed vehicles for bottle delivery. *Sean Duranovich.*

city was quickly dwindling due to new regulations. Additionally, that number constitutes just over half of the licenses in the city. The figure is likely a conflation of the total number of taverns owned over a period of about two decades by Robert T. Davies and his son, Robert W. Davies, who worked for the Davies Brewery and the Copland Brewery. It would not have been a sound investment strategy at any rate.

Davies had been independently wealthy since 1890 and found himself retiring from the brewing industry in 1900 at the age of fifty-one. He had married Margaret Anne Taylor in 1871, daughter of John Taylor, whose family had owned 144 acres in the Don Valley. Three important landmarks resulted from the marriage. For one, Davies's home, Chestnut Park, was located just off Broadview Avenue and had a commanding view of the Don Valley. Just across the valley was Davies's stable, which composed the entirety of the Thorncliffe neighbourhood, a fiefdom large enough to earn him the nickname "King Bob" in the racing world. Finally, there was the Don Valley Brick Works, which Davies acquired in 1901 and subsequently built into the largest enterprise of its kind in the world.

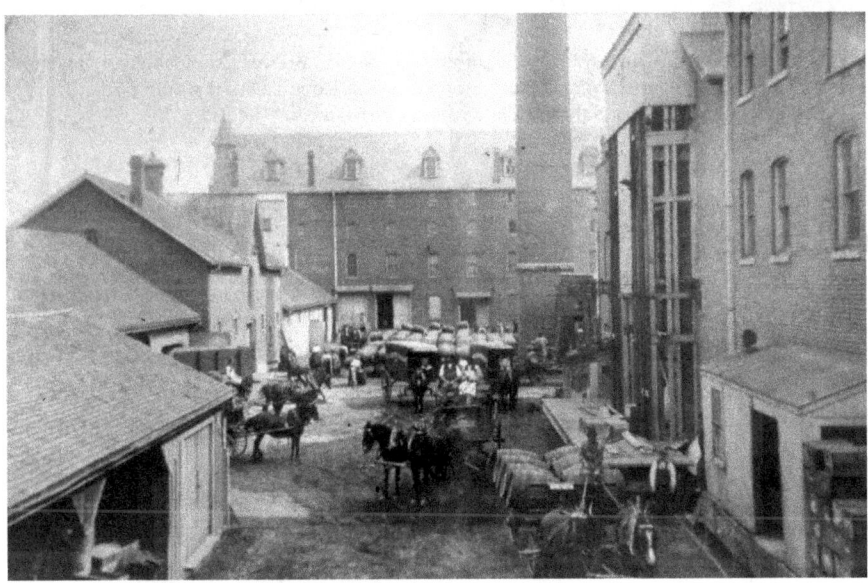

The southern courtyard of the Dominion Brewery was used for returns rather than outgoing product. In the background of the shot, the returned barrels wait to be cleaned for reuse, while the bottling section is in the foreground on the right. *Sean Duranovich.*

The Dominion Hotel, which was attached to the Dominion Brewery, stands to this day and is one of the city's few remaining Victorian hotels. What Robert Davies would think of the weekly Ukulele Jam, we can only speculate. *Toronto Beer Week.*

Robert Davies passed away in 1916 and left a legacy as a world beater. In all things, he strove to be the best. He was the only man in history to have jockeyed, trained, owned and raced horses in the Queen's Plate. All of the businesses in which he was involved found themselves the largest in the country, at least for a time. His White Label Ale was entered in more international competitions and won more medals than any other beer in Ontario. However, his drive to succeed left a state of affairs at the end of his life where he was being sued by his extended family for having taken advantage of them in business related to the brickworks. He owned the deeds to nearly $1 million in real estate but provided for less than $4,000 in philanthropic donation. Unlike some of his contemporaries, Robert Davies was not especially interested in the betterment of society. Robert Davies was only interested in winning.

The Dominion Brewery was less successful without Davies's monomaniacal drive. In 1926, it was purchased by the Hamilton Brewing Association. In 1930, the properties of the Hamilton Brewing Association were purchased

by E.P. Taylor and formed part of the original basis of his empire. By 1936, the Dominion Brewery was considered redundant, and production was shifted to the Cosgrave Brewery. The Dominion Hotel, which was located adjacent to the brewery, has been rebranded the Dominion on Queen and continues to serve beer produced locally.

SELECTED BIBLIOGRAPHY

A brief bibliographic note: I have attempted in writing this book to use primary documents in research whenever possible. Not only does this provide the advantage of not relying on secondary resources, which may have misinterpreted basic geographical and technical information, but it also provides greater context for the lives and stories of the men and women who made Victorian Toronto a brewing capital. An advantage I have had is that the entire archives of the *Globe*, *Toronto Daily Mail*, *Toronto Star* and *Toronto World* have been digitized. Because I have sifted through several hundred years of newspaper archives over the course of approximately half a year, listing the actual articles would require an additional book as long as the one you currently hold. The same can easily be said of the numerous sets of digitized parish records that account for the provenance of the early brewers in Ontario. This is, perforce, a selected bibliography. If this were a doctoral dissertation, I would be in a lot of trouble.

Bowering, Ian. *The Art and Mystery of Brewing in Ontario*. Renfrew, ON: General Store Publishing House, 1989.

Canadian Brewerianist Society Convention. *Toronto Brewing History Guide & Convention Programme, August 8–12, 2001, Crowne Plaza Hotel, Don Valley.* Toronto: Canadian Brewerianist Society, 2001.

Selected Bibliography

Copland, William. *Narrative of the Early Events of the Rebellion in Upper Canada: With Observations on the Political State of America, Being Extracts of Letters from Mr. William Copland, Formerly and Norfolk Yeoman, Now a Resident at Toronto.* Holt, Norfolk, UK: J. Shalders, 1838.

Coutts, Ian. *Brew North: How Canadians Made Beer and Beer Made Canada.* Vancouver: Greystone Books, 2010.

Dominion Brewers Association. *Facts on the Brewing Industry in Canada.* Montreal: Federated Press Limited, 1948.

Ferguson, Adam. *Practical Notes Made During a Tour in Canada, and a Portion of the United States, in MDCCCXXXI.* Edinburgh, UK: William Blackwood, 1833.

Helliwell, William. *Helliwell Diaries.* Toronto: City of Toronto Museum Services, 1830–90.

McLeod, Alan, and Jordan St. John. *Ontario Beer: A Heady History of Brewing from the Great Lakes to the Hudson Bay.* Charleston, SC: The History Press, 2014.

Mulvany, Charles Pelham. *Toronto, Past and Present: A Handbook of the City.* Toronto, W.E. Caiger, 1884.

Mulvany, Charles Pelham, and Graeme Mercer Adam. *History of Toronto and County of York, Ontario: Containing an Outline of the History of the Dominion of Canada; a History of the City of Toronto and the County of York, with the Townships, Towns, General and Local Statistics; Biographical Sketches.* Vol. 1. Toronto: C.B. Robinson, 1885.

Oliver, Garrett, ed. *The Oxford Companion to Beer.* Oxford: Oxford University Press, 2011.

Pearson, W.H. *Recollections and Records of Toronto of Old: With References to Brantford, Kingston and Other Canadian Towns.* Toronto: William Briggs, 1914.

Robertson, John Ross. *Robertson's Landmarks of Toronto: A Collection of Historical Sketches of the Old Town of York from 1792 Until 1837, and of Toronto from 1834 to 1914.* Toronto: John Ross Robertson, 1914.

SELECTED BIBLIOGRAPHY

Robinson, C.B. *History of Toronto and County York, Ontario: Biographical Notices.* Toronto: self-published, 1885.

Sauriol, Charles. *Remembering the Don: A Rare Record of Earlier Times within the Don River Valley.* Toronto: Dundurn Group, 1981.

Scadding, Henry. *Toronto of Old: Collections and Recollections Illustrative of the Early Settlement and Social Life of the Capital of Ontario.* Toronto: Adam, Stevenson and Company, 1878.

Sneath, Allen Winn. *Brewed in Canada: The Untold Story of Canada's 350-Year-Old Brewing Industry.* Toronto: Dundurn Group, 2001.

Timperlake, J. *Illustrated Toronto, Past and Present: Being an Historical and Descriptive Guide-Book, Comprising Its Architecture, Manufacture, Trade, Its Social, Literary, Scientific, and Charitable Institutions, Its Churches, Schools, and Colleges, and Other Principal Points of Interest to the Visitor and Resident, Together with a Key to the Publisher's Bird's-Eye View of the City.* Toronto: Peter A. Gross, 1877.

INDEX

A

Aldwell, John 105, 108, 115, 118, 120, 125
Aldwell, Louisa 120
Aldwell, Thomas 115, 120
Aldwell, Thomas Theobald 117
Allen, Oliver Henry 79
Allen, Thomas 78, 79
Ashbridges Bay 13, 14

B

Baines, Thomas 72, 97
Ball, John 68
Battle of York 11
Blake, J.N. 120
Bloore, John Helliwell 45, 49
Bloore, Joseph 41, 45, 46, 48, 59
Boord, Sir Thomas 142
Boulton, D'Arcy 56
Bright, Betsey 41
Brown, George 67, 119

C

Canada Brewers and Maltsters Association 62
Canada Bud Brewery 122
Castle Frank Brewery 48
Castle Frank Brook 14, 46, 59, 60, 61
Cayley, Francis Melville 55
Cayley, John 55, 57
Cayley, William 55, 57
Chevallier Barley 119
City Club Brewery 74, 123
Colborne, Sir John 38
Consumers Gas Works 53
Copland, William 87, 93
Copland, William, Jr. 88
Cornnell, John S.G. 68, 83, 84, 122
Cosgrave, James 101
Cosgrave, James F. 102, 103, 104
Cosgrave, John 99, 100, 101
Cosgrave, Lawrence Moore 102

INDEX

Cosgrave, L.J. 99, 101
Cosgrave, Patrick 98, 99, 105, 106
Craig, George 66

D

Davies, Carrie Evelyn 83
Davies, J.E. 84
Davies, John 127
Davies, Joseph J. 129
Davies, Nathaniel 127
Davies, Robert T. 78, 83, 93, 129, 131, 135, 137, 138, 145
Davies, Robert W. 93, 145
Davies, Thomas 127, 128
Davies, Thomas, Jr. 128, 129, 132, 135, 137
Davies, Thomas, Sr. 77
Defries, Robert H. 78
Defries, Robert W. 77, 78
Defries, Thomas W. 78, 138
Denison, George Taylor 66
Dick, John 133, 135
Doel, John 20, 23, 25, 29
Drumsnab 56
Dunkin Act 63

E

Eastwood, John 34, 35
Enoch Turner Schoolhouse 52
Esplanade, the 13

F

Family Compact 9
Farmer's Arms, the 45, 47, 51
Farr, Elisha 27

Farr, James 27, 28, 29
Farr, John 27, 29, 38, 97
Fort Frontenac 11, 17
Fort Rouillé 17
Fort York 11, 12, 17, 24, 28

G

Garrison Creek 14, 28
Germania Hotel, the 70, 73
Gooderham and Worts 53, 71
Gossage, Brooks Wright 120
Grand Trunk Railway 10, 57
Great Western Railway 10
Greey, Samuel 67
Group of Seven 64

H

Haldane, Hudson Coldwell 89
Haldane, William 89, 90
Hannath, Charles 105, 115
Hart, George 105, 115
Hawke, George 105
Helliwell, Thomas, Jr. 35
Helliwell, Thomas, Sr. 33
Helliwell, William 34, 38, 45
Henderson, Robert 18, 19
Hime, Humphrey Lloyd 88, 91, 120
Hodgson, Charles 101
Howard, John George 52, 56, 129
Howland, William 121
Humber River 27

I

Irish Famine 10, 15

INDEX

J

Jardine, Arbuckle 68
Jarvis, William Botsford 47, 59
Jewell, Jane Luke 21
Jewell, Richard 21

K

Ketchum, Jesse 24
Kiewel, Charles 123
Kormann, Franz J. 73
Kormann, Ignatius 72, 79
Kormann, John S. 73, 74
Kormann, Joseph 73
Kormann, Theresa 73

L

Lynch, John 20

M

Mackenzie, William Lyon 26, 29, 39, 40
Malcolm Cameron 116
Manning, Alexander 121
McKay, Adam 66, 67
McLaren, Duncan 123
Miles, Abner 20
Millar, Charles 112
Montgomery's Tavern 25, 47
Moss, Charles 31
Moss, John 30, 31, 98
Moss, Thomas 31
Mulvany, Charles Pelham 59, 89

N

Nash, John 56, 57

O

O'Keefe, Eugene 71, 98, 100, 105, 107, 108, 109
O'Keefe, Eugene Bailey 110
Ontario Brewing and Malting Company 90, 91, 92, 96, 132

P

Parks, Robert 128
Parks, William 128
Peacock Inn 29
Pearson, W.H. 10, 16
Pellatt, Sir Henry Mill 112
Platt, Samuel 52, 79
Playter, Ely 20
Pope Pius X 110

Q

Queen City Malting 90

R

Red Lion Inn 39, 60
Reinhardt, Alphonso 83
Reinhardt, Amanda 82
Reinhardt, Arthur 83
Reinhardt, Ernest 83
Reinhardt, Lothar 72, 79, 82, 83, 100
Reinhardt, Lothar, Jr. 83
Robertson, John Ross 10, 28
Robinson, Peter 41, 72, 97
Rose, John 48
Russell Creek 65, 68
Russell, Peter 65

INDEX

S

Salvador 81
Scadding, Henry 10, 23, 64
Scott, William 119
Severn, George 61, 63
Severn, Henry 61
Severn, John 59, 61
Severn, William 62
Shaw, George 19
Shaw, Joseph 19
Sherbourne Brewery 20, 21
Simcoe, John Graves 9, 18
Small, Ambrose 73, 75
Sproatt, Charles 67, 98, 99
Sproatt, Henry 66
St. Augustine's Seminary 112
St. Leger Race Course 66
Stoyell, Thomas 19, 20, 23, 35
Stuart, John 18

T

Taddle creek 18
Taddle Creek 14, 18, 52, 87
Taylor, Edward Plunkett 75, 85, 96, 104, 112, 125, 147
Taylor, George 93
Taylor, Margaret Anne 145
Taylor, Thomas Bright 90, 91, 92, 93
temperance movement 16, 73, 132, 135
Thomas, Charles 101
Thompson, Charles 98
Thompson, Hugh 78, 79
Thompson, Isaac 97
Thomson, Tom 64
Todmorden Mills 45

Toronto Brewers' Association 16
Toronto Harbour Commission 13
Turner, Enoch 51, 53, 79

W

Walker, John 66
Wallis, John 30
Walz, John 70, 71, 79
William Simon Brewery 94
Wismer, Pat 95

Y

Yorkville 12, 60
Yorkville Waterworks 63

ABOUT THE AUTHOR

Jordan St. John is Canada's only nationally syndicated beer columnist, for Sun Media, and is the author of the blog "St. John's Wort." He is a Certified Cicerone and periodically brews beers in collaboration with brewers around Ontario. He is the coauthor with Mark Murphy of *How to Make Your Own Brewskis: The Go-To Guide for Craft Brew Enthusiasts*. This is his second historical work, the first being *Ontario Beer: A Heady History of Brewing from the Great Lakes to the Hudson Bay* with Alan McLeod.

Visit us at
www.historypress.net

This title is also available as an e-book

www.ingramcontent.com/pod-product-compliance
Lightning Source LLC
Chambersburg PA
CBHW071410160426
42813CB00085B/923